Magical Fairies & Flowers

A Find-the-fairy-on-each-page Coloring Book

42 beautiful and elaborate hand-drawn pictures

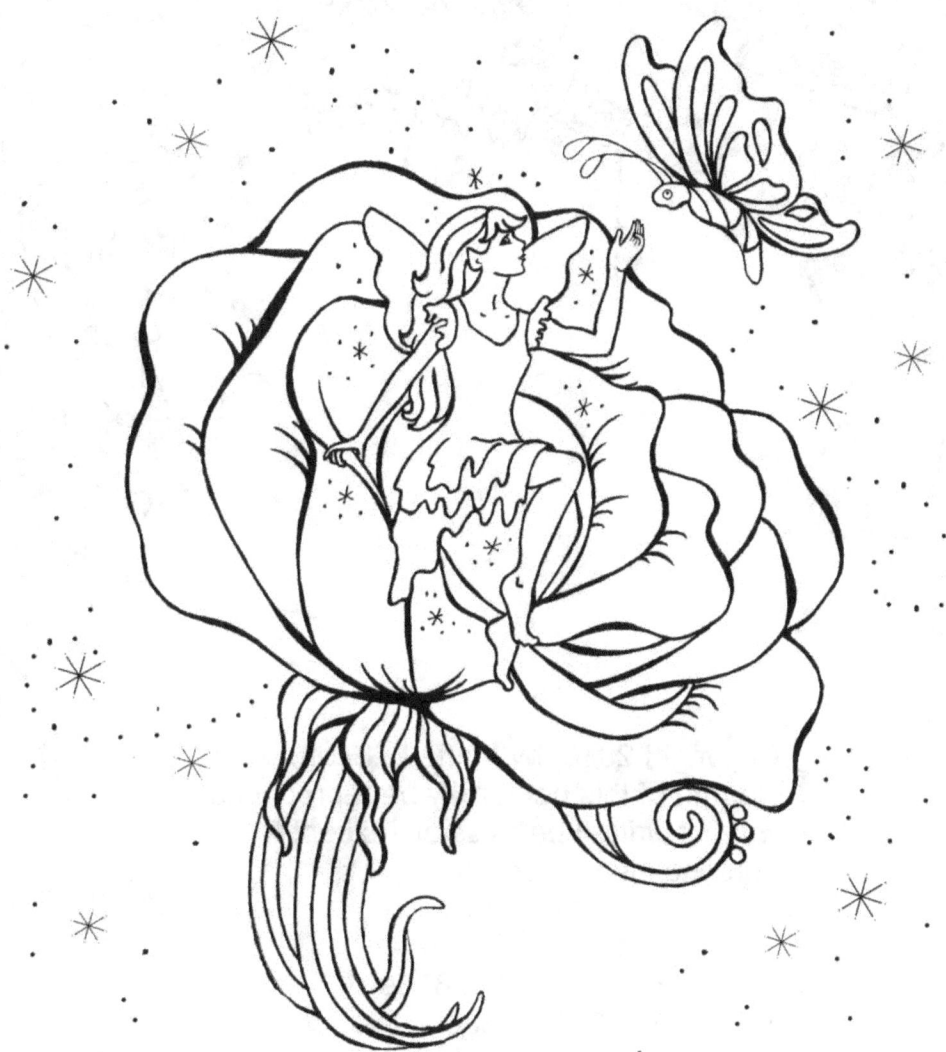

by Marie Scott

Copyright 2016, by Marie L. Scott.
No part of this book may be reproduced without written permission, except for personal home use.

ISBN-13: 978-1539766889
ISBN-10: 1539766888

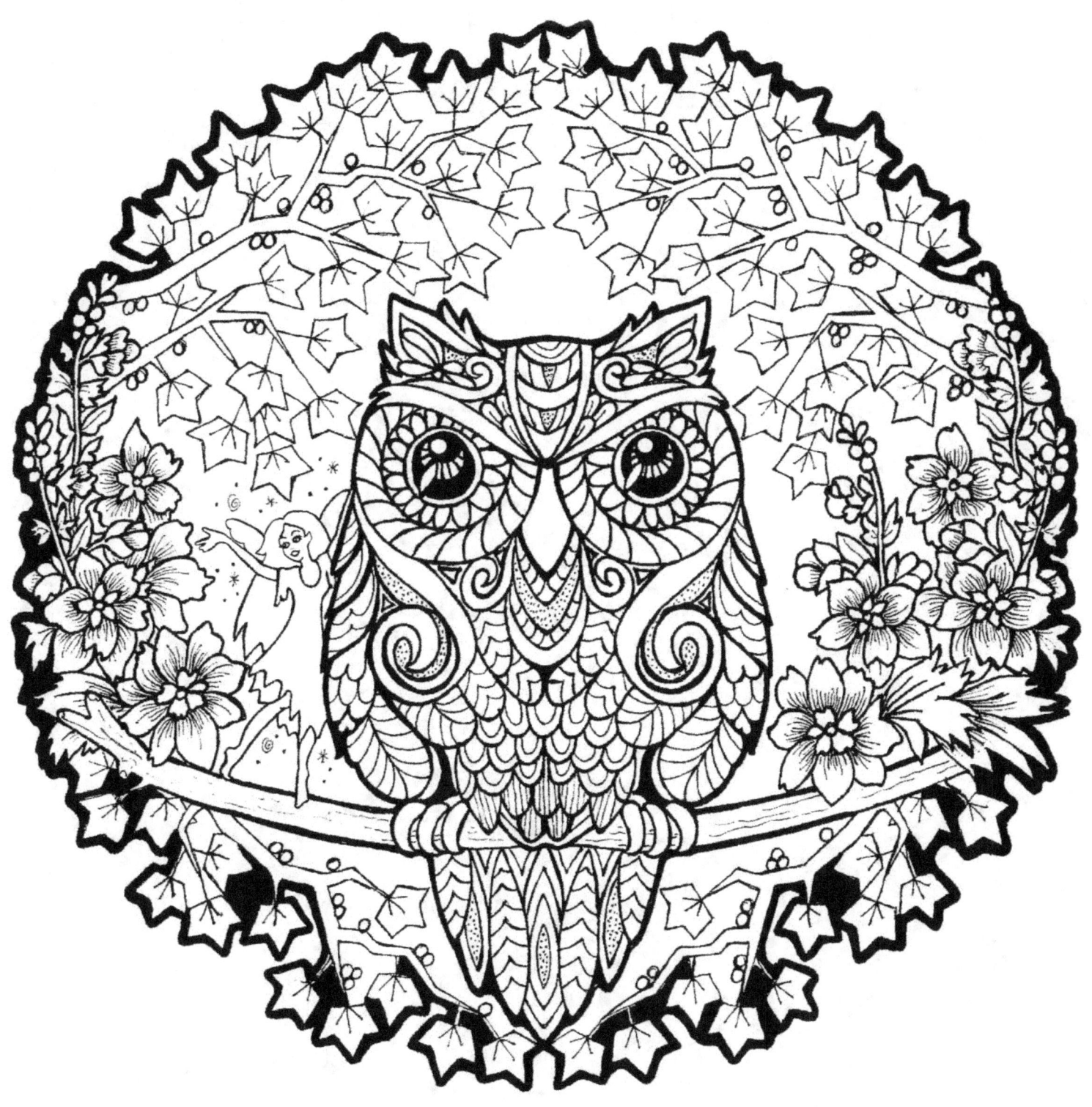

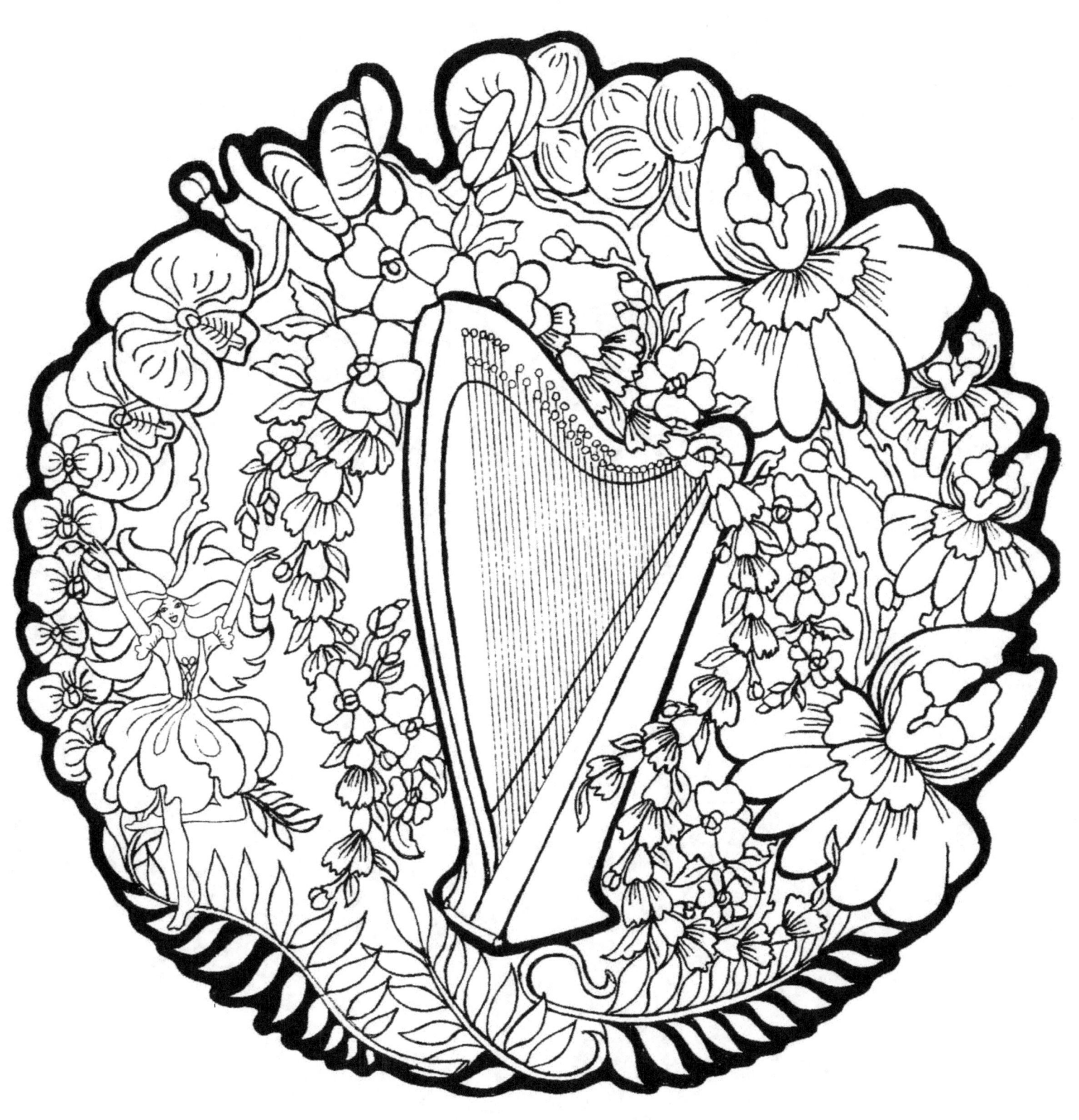

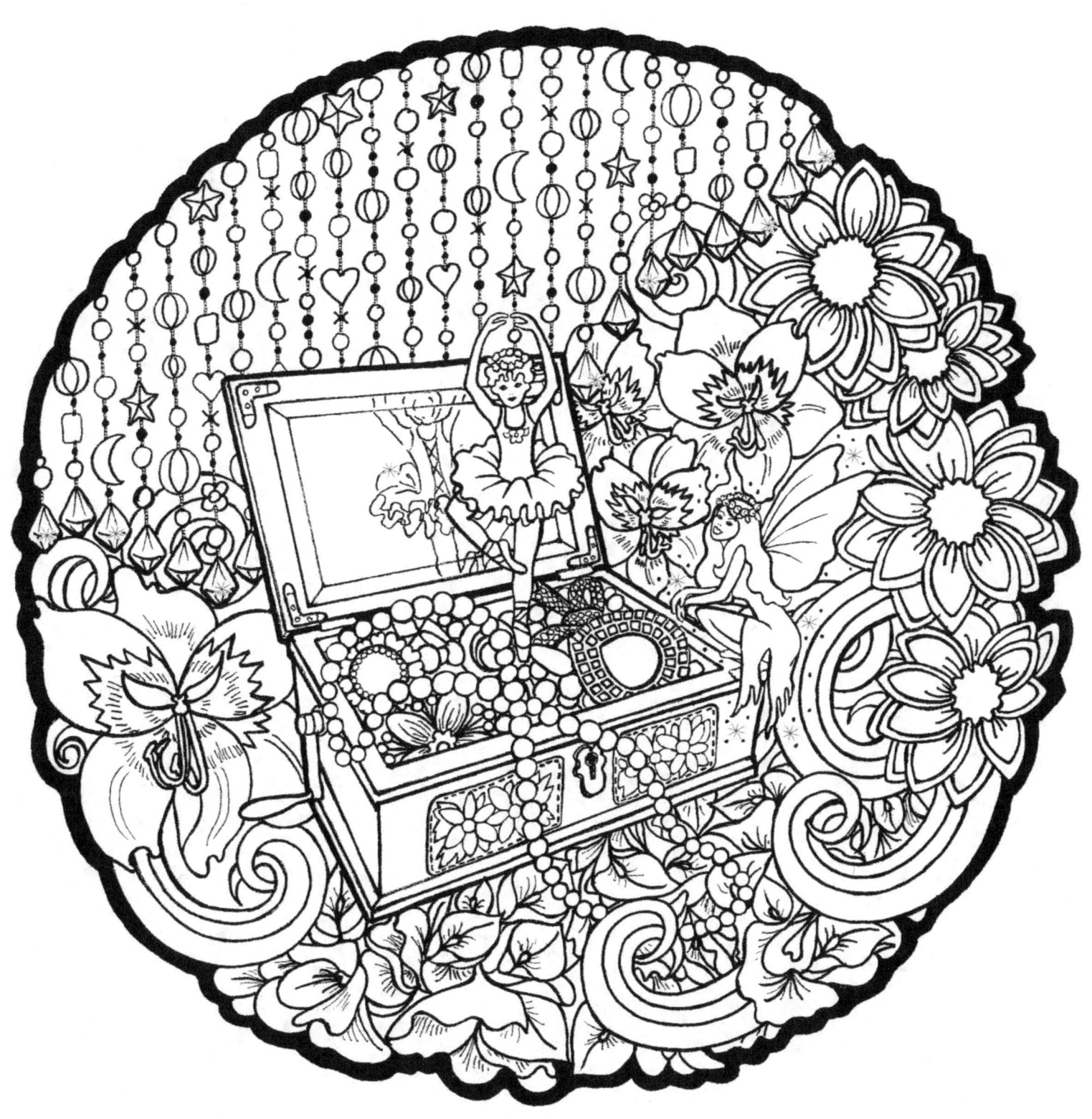

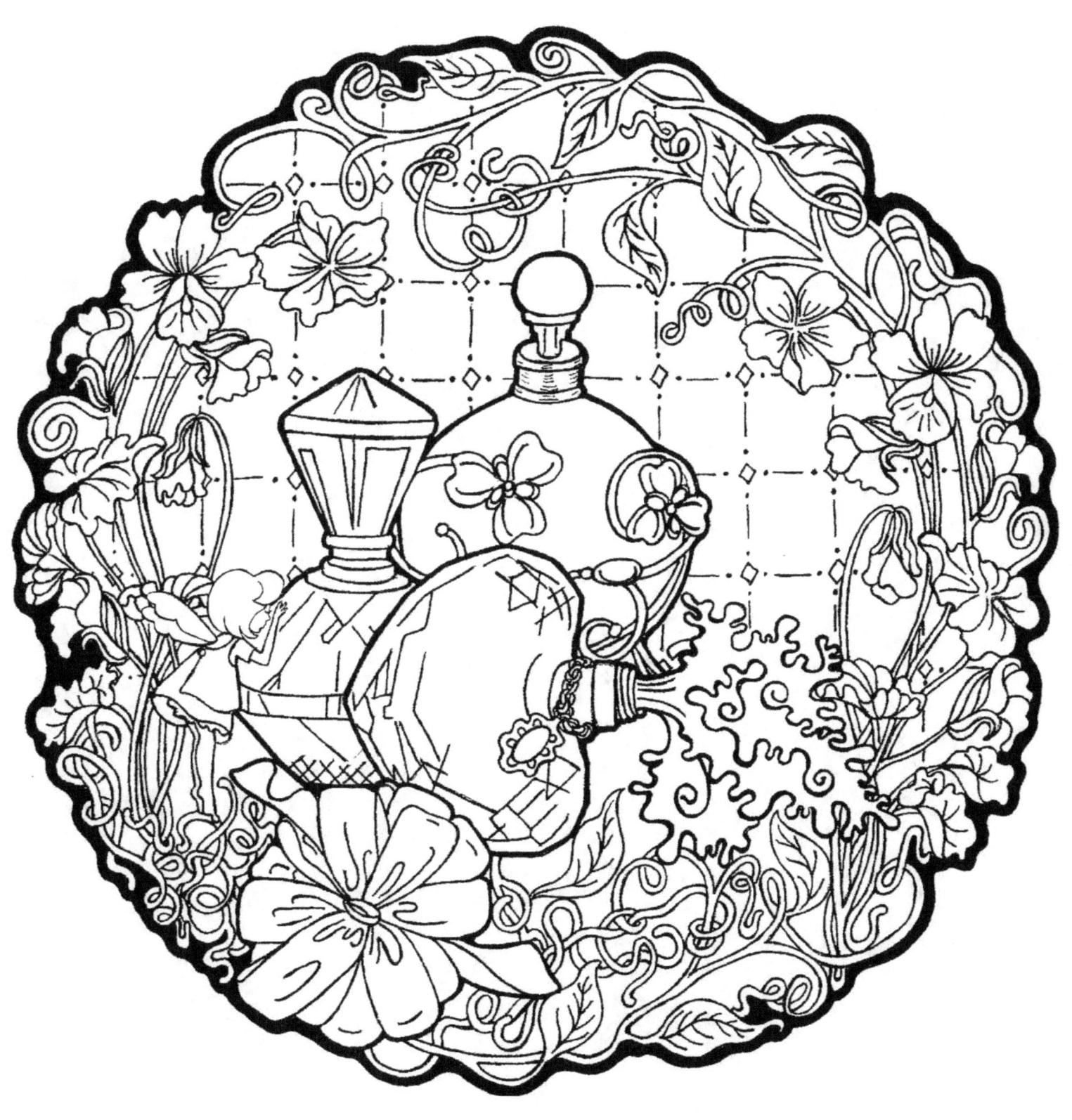

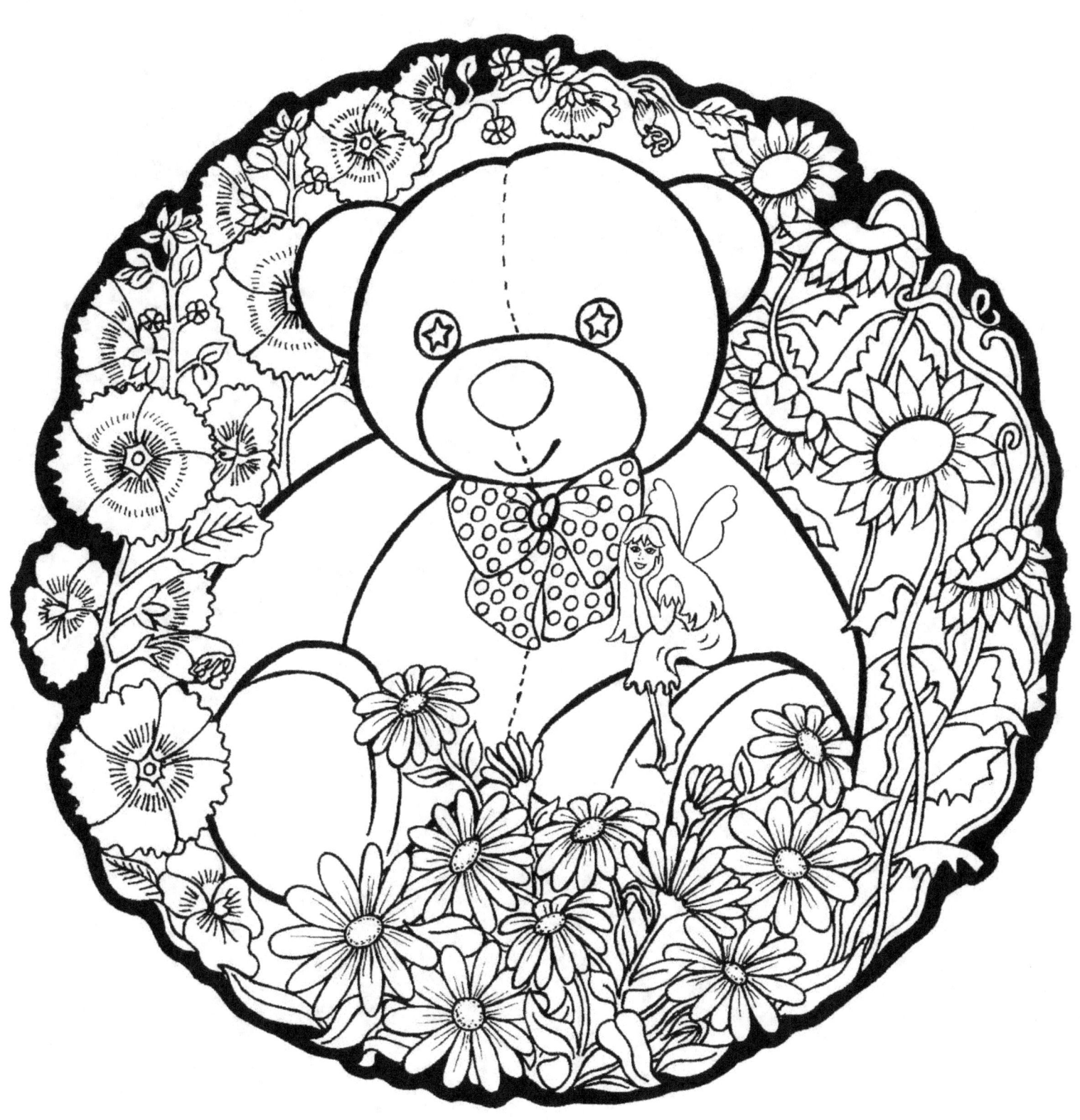

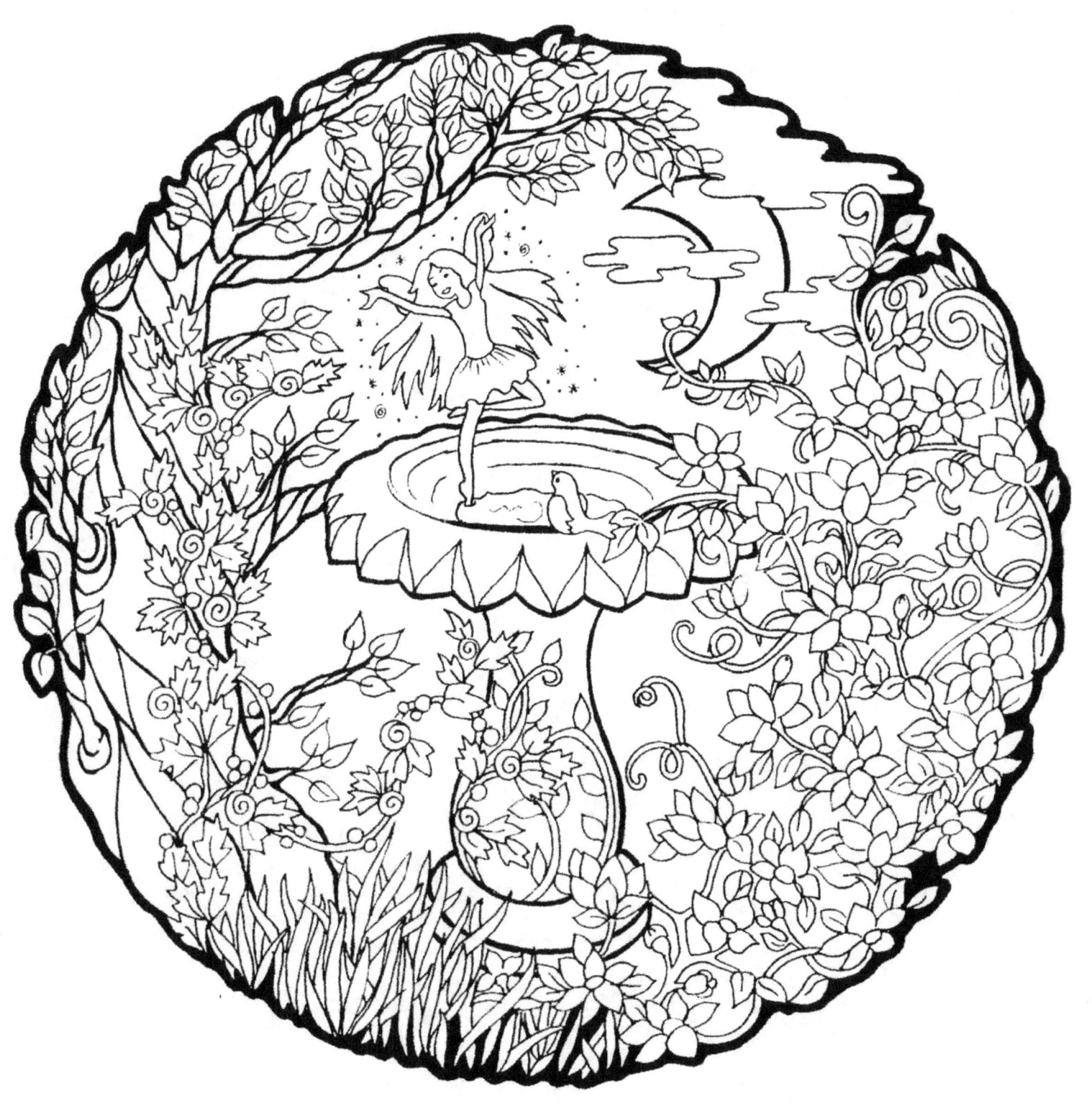

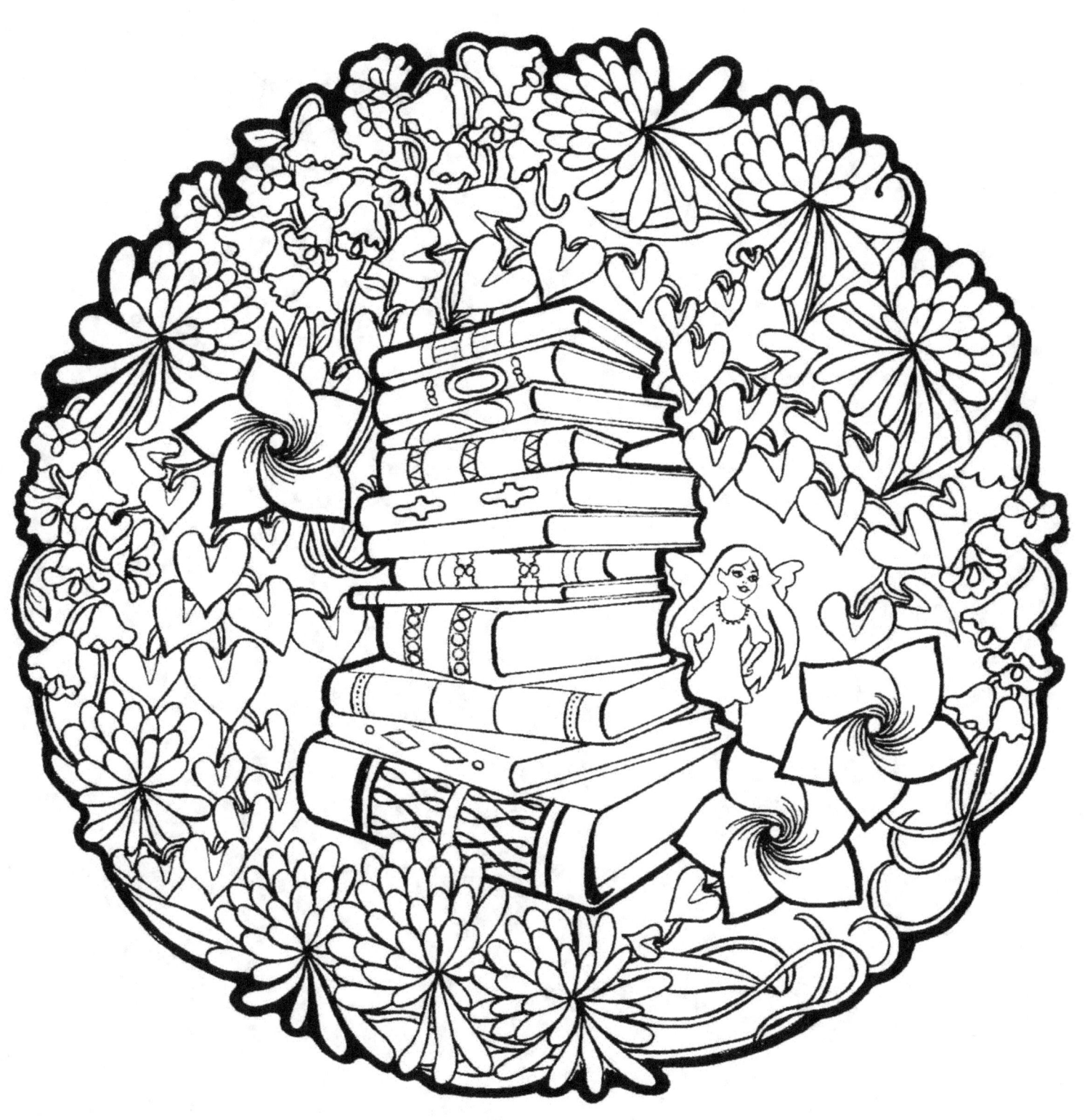

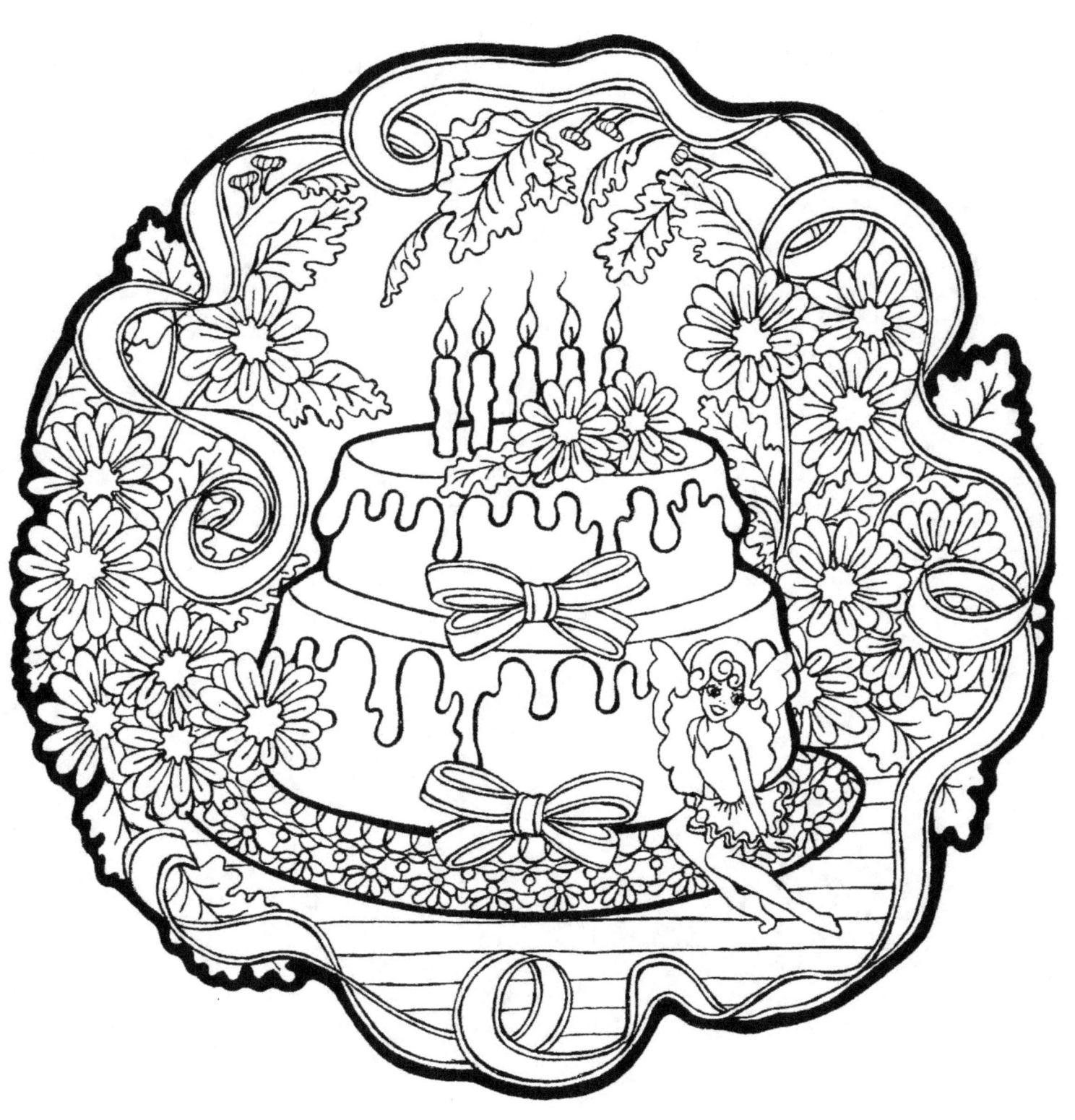

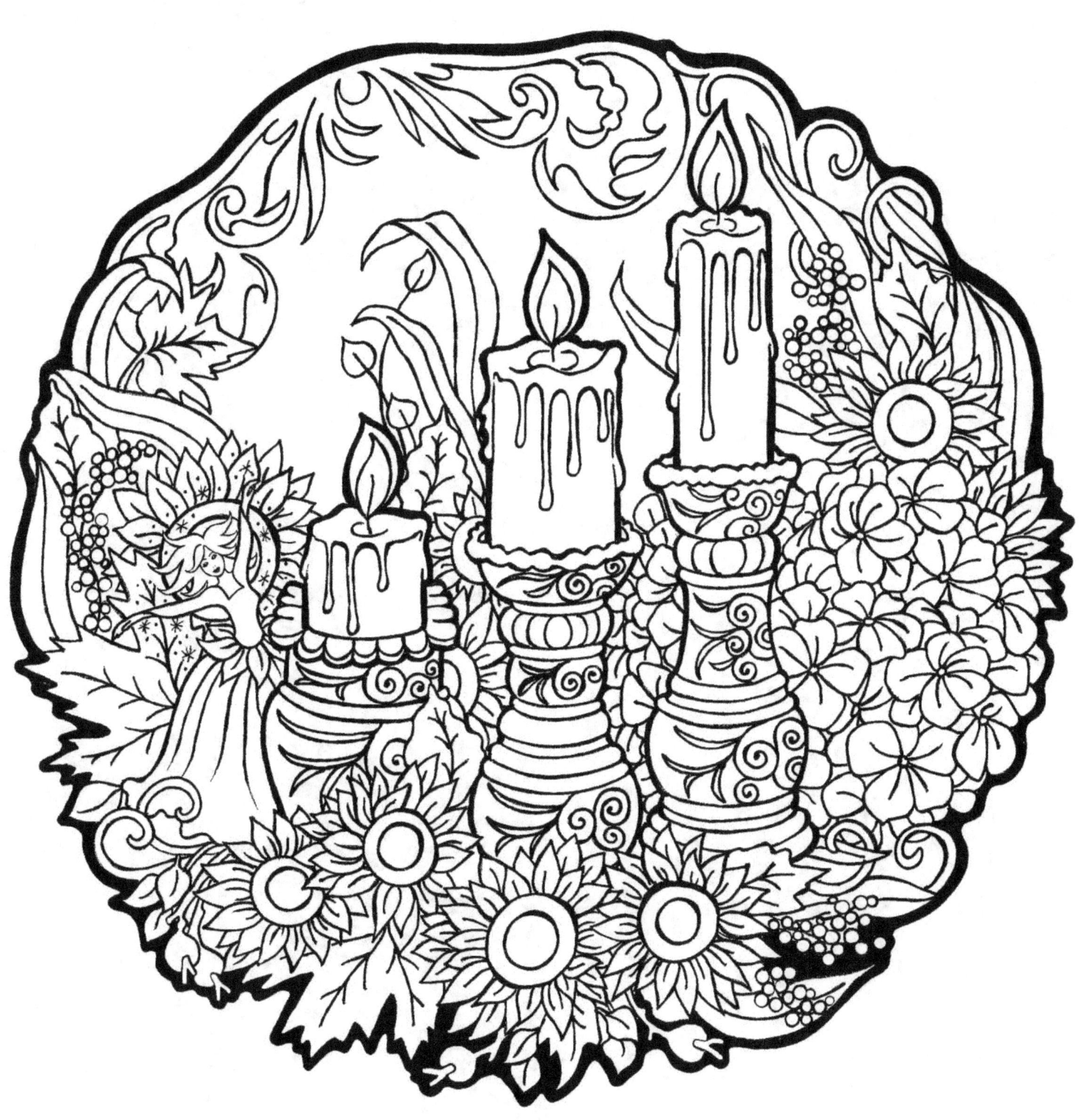

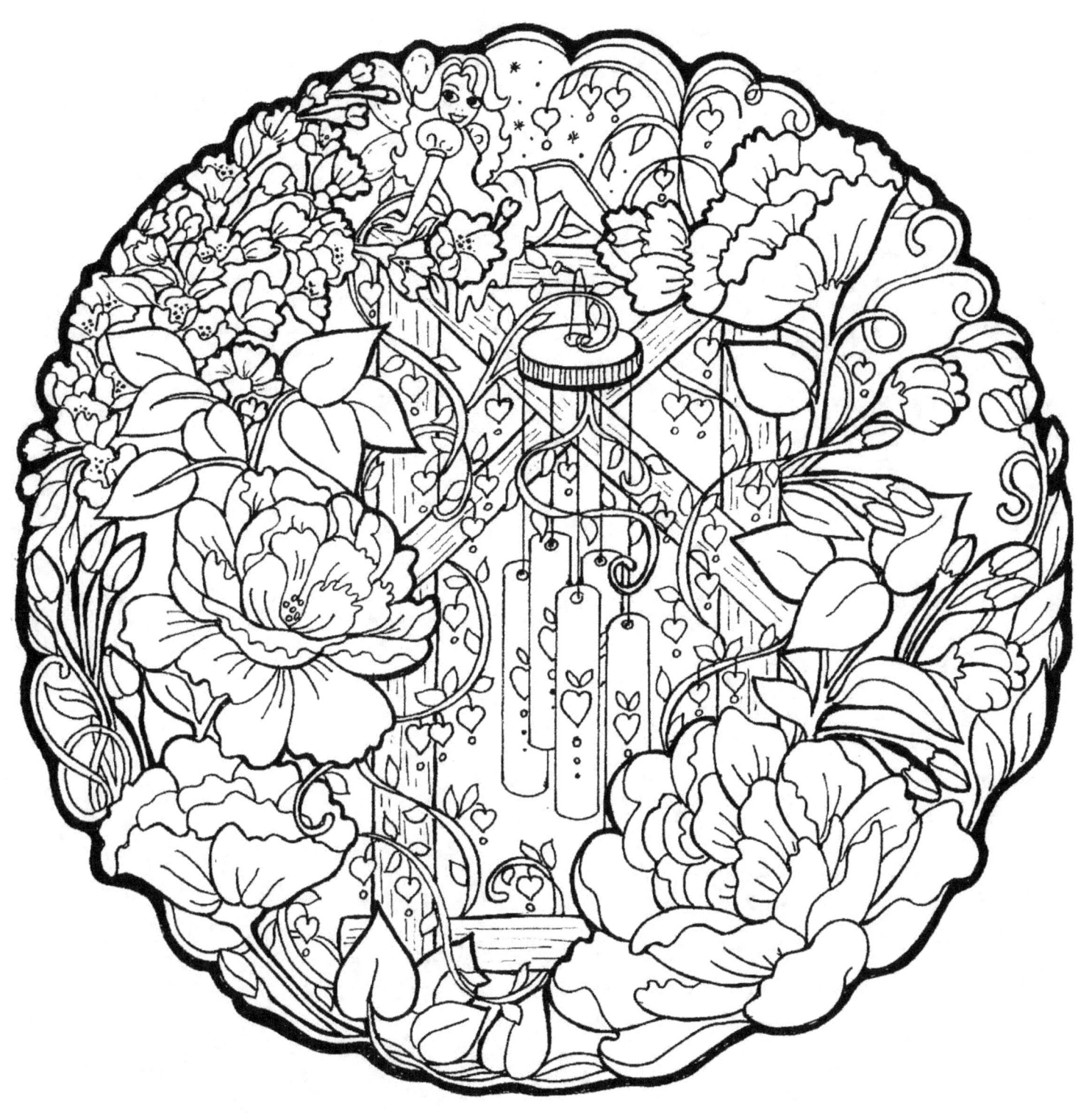

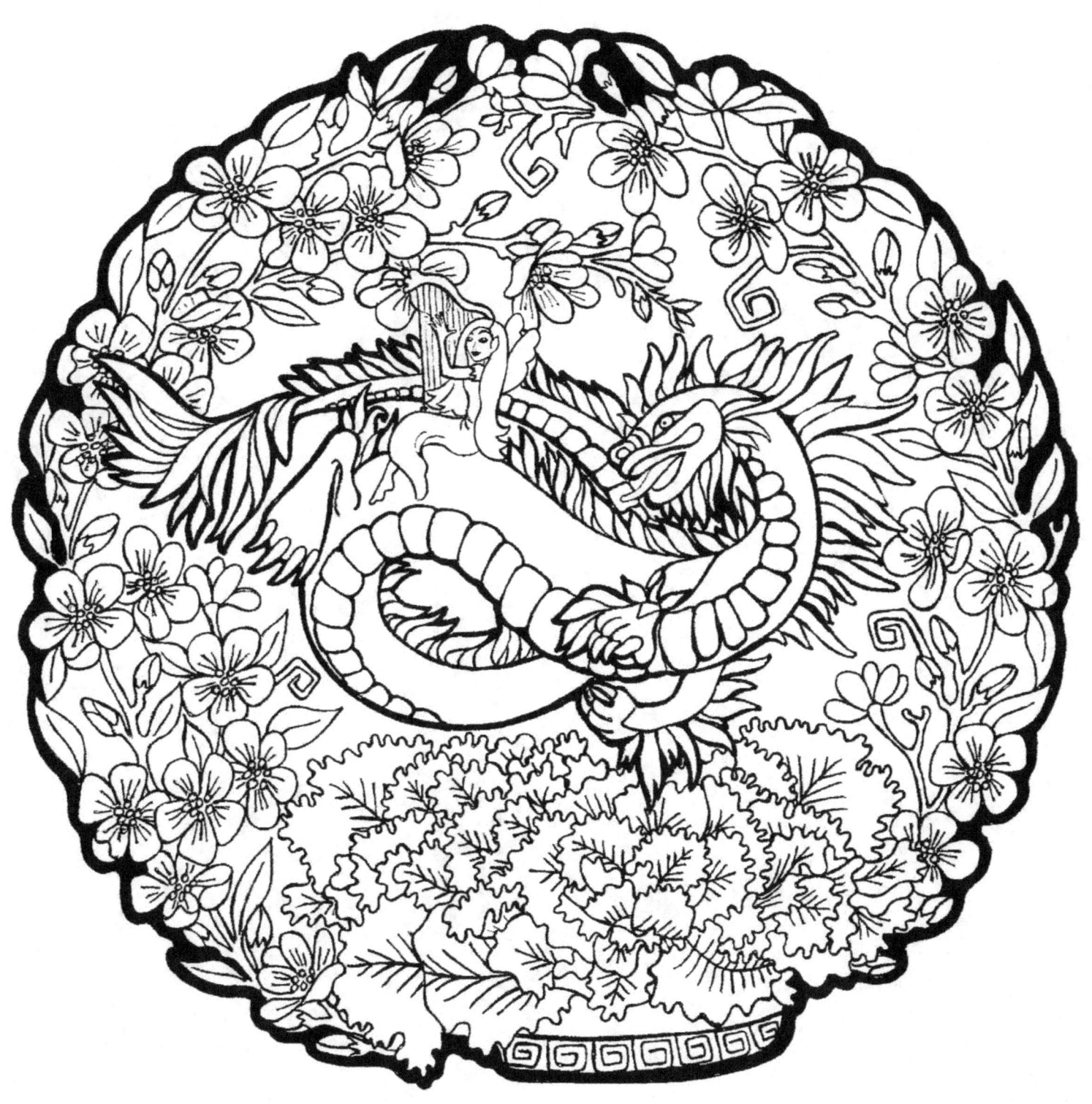

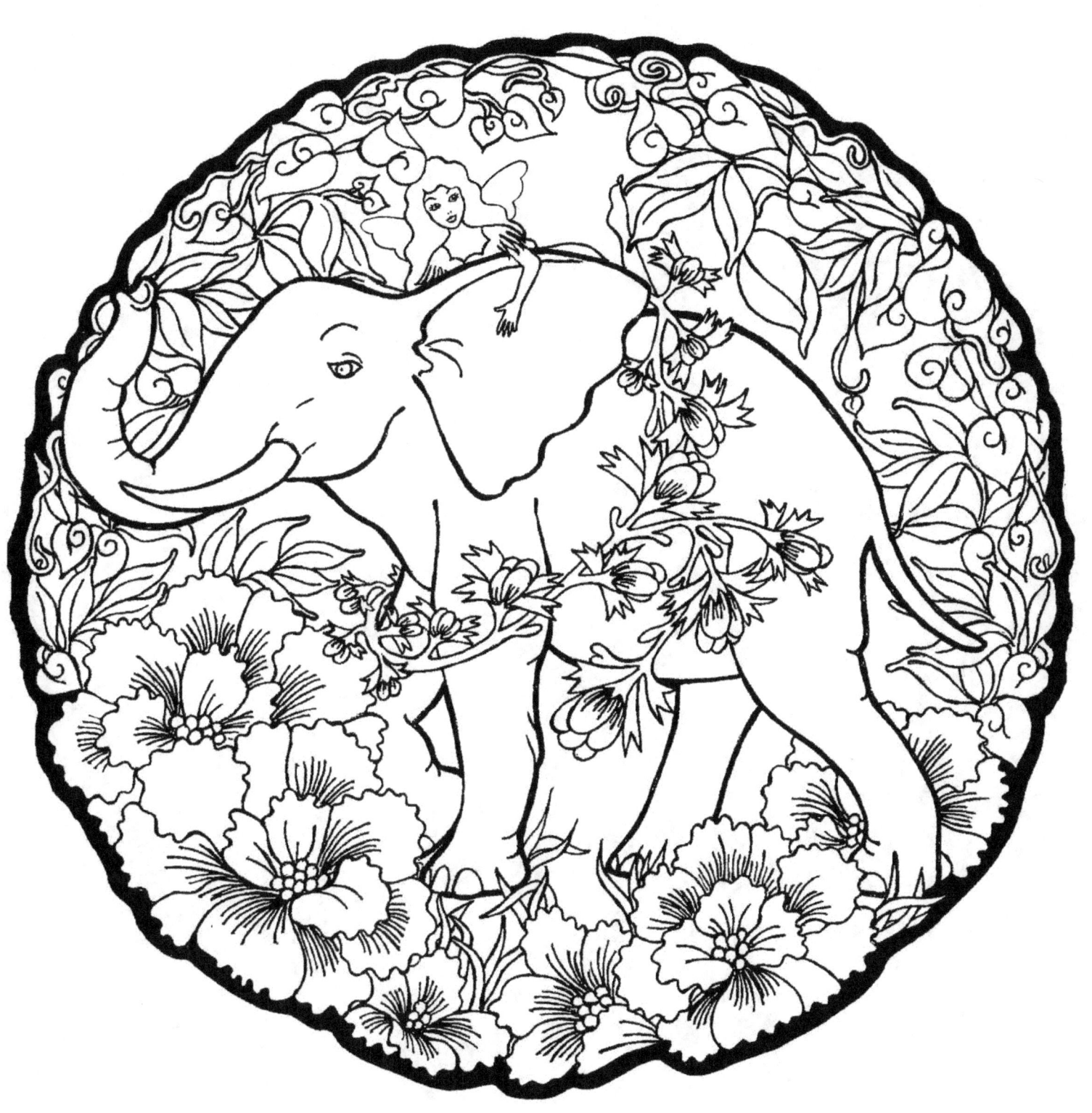

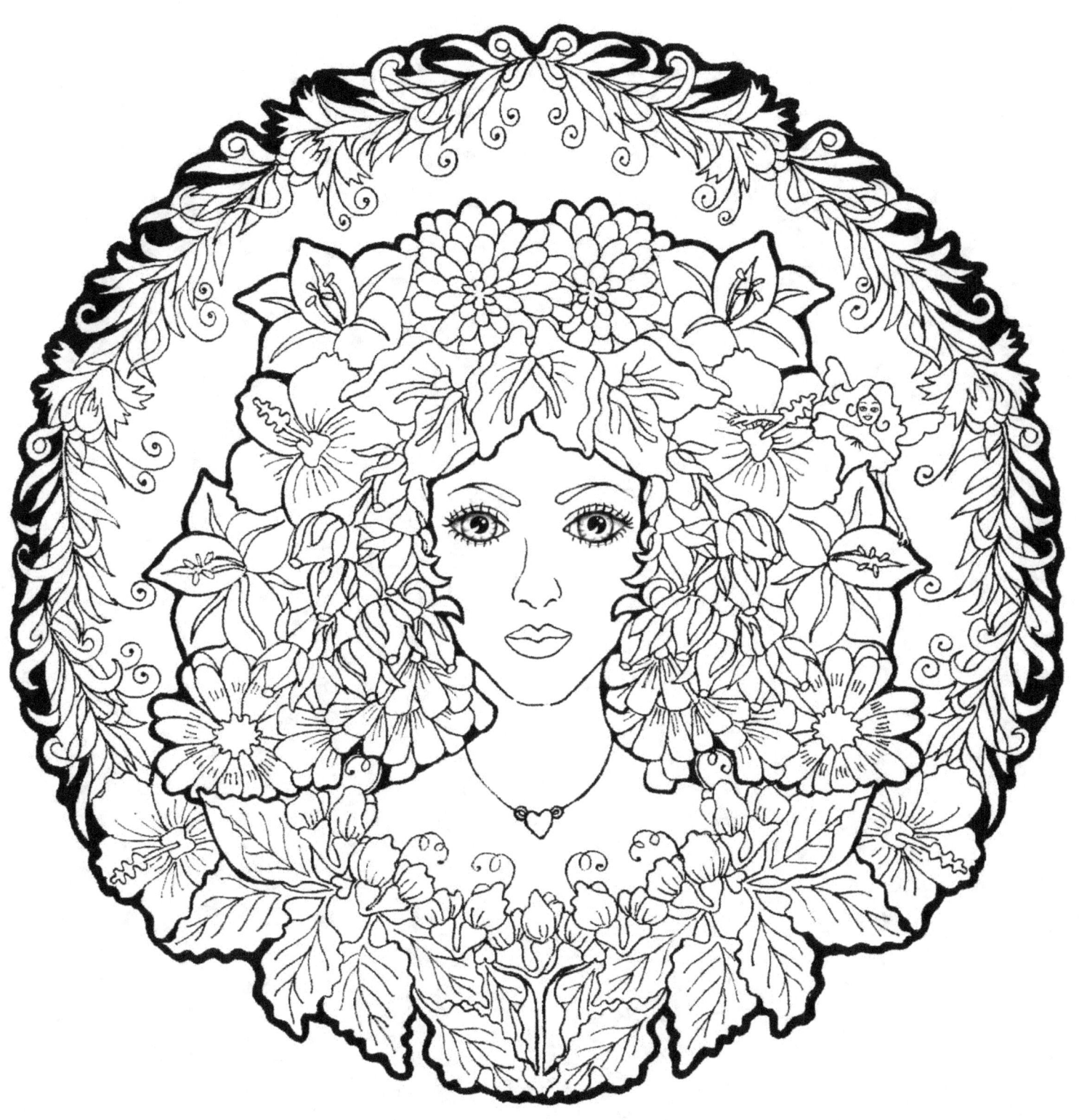

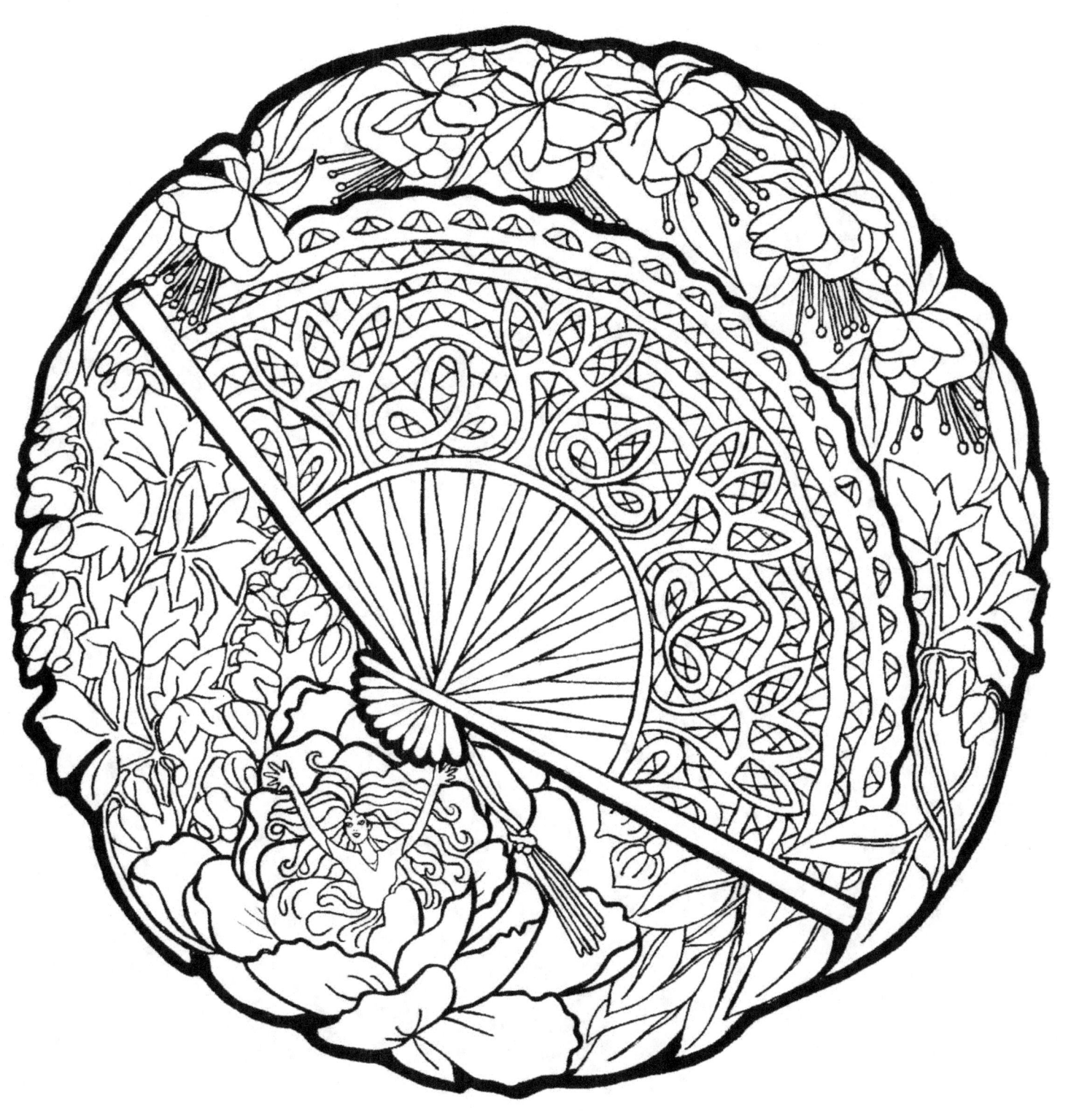

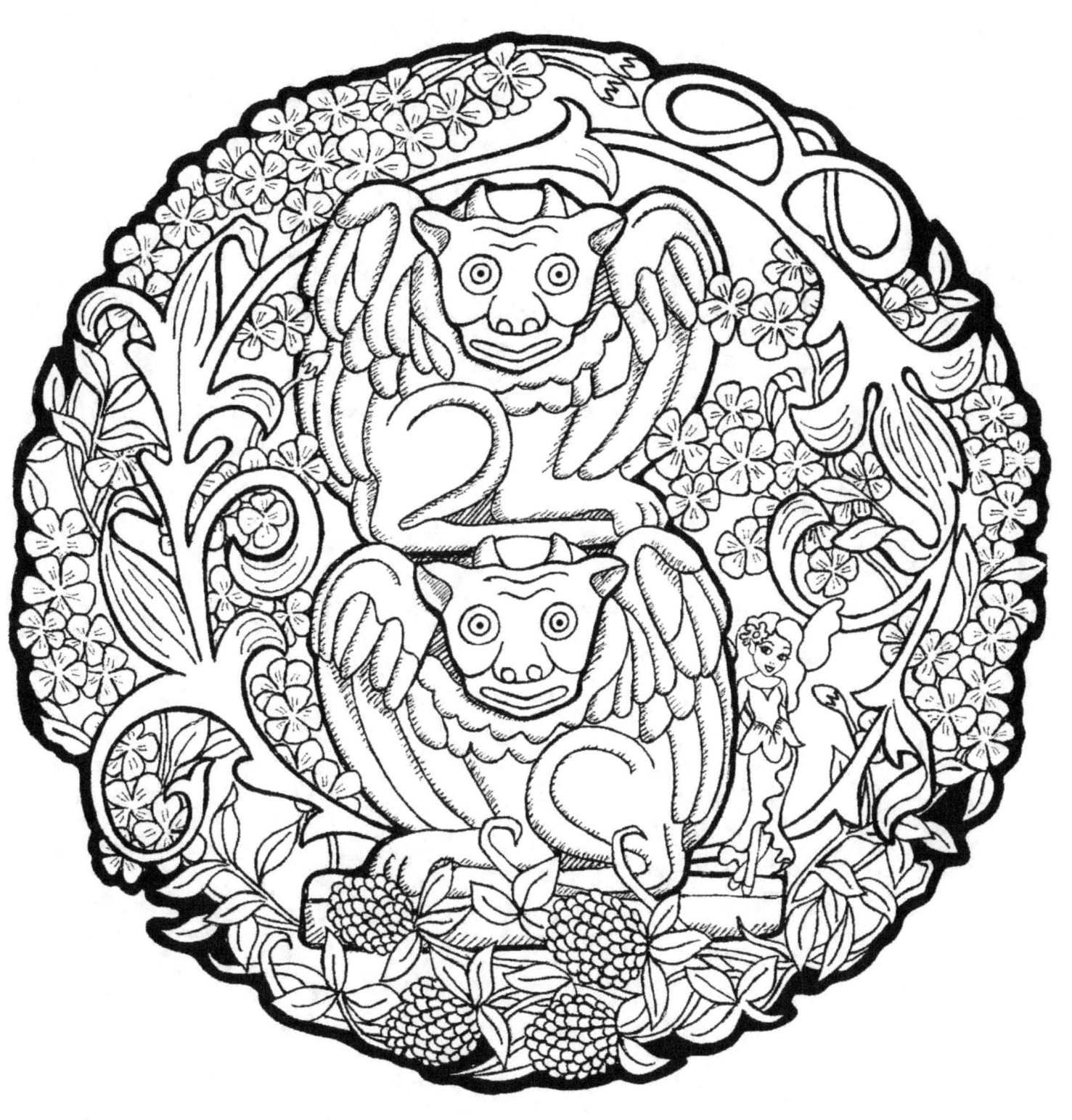

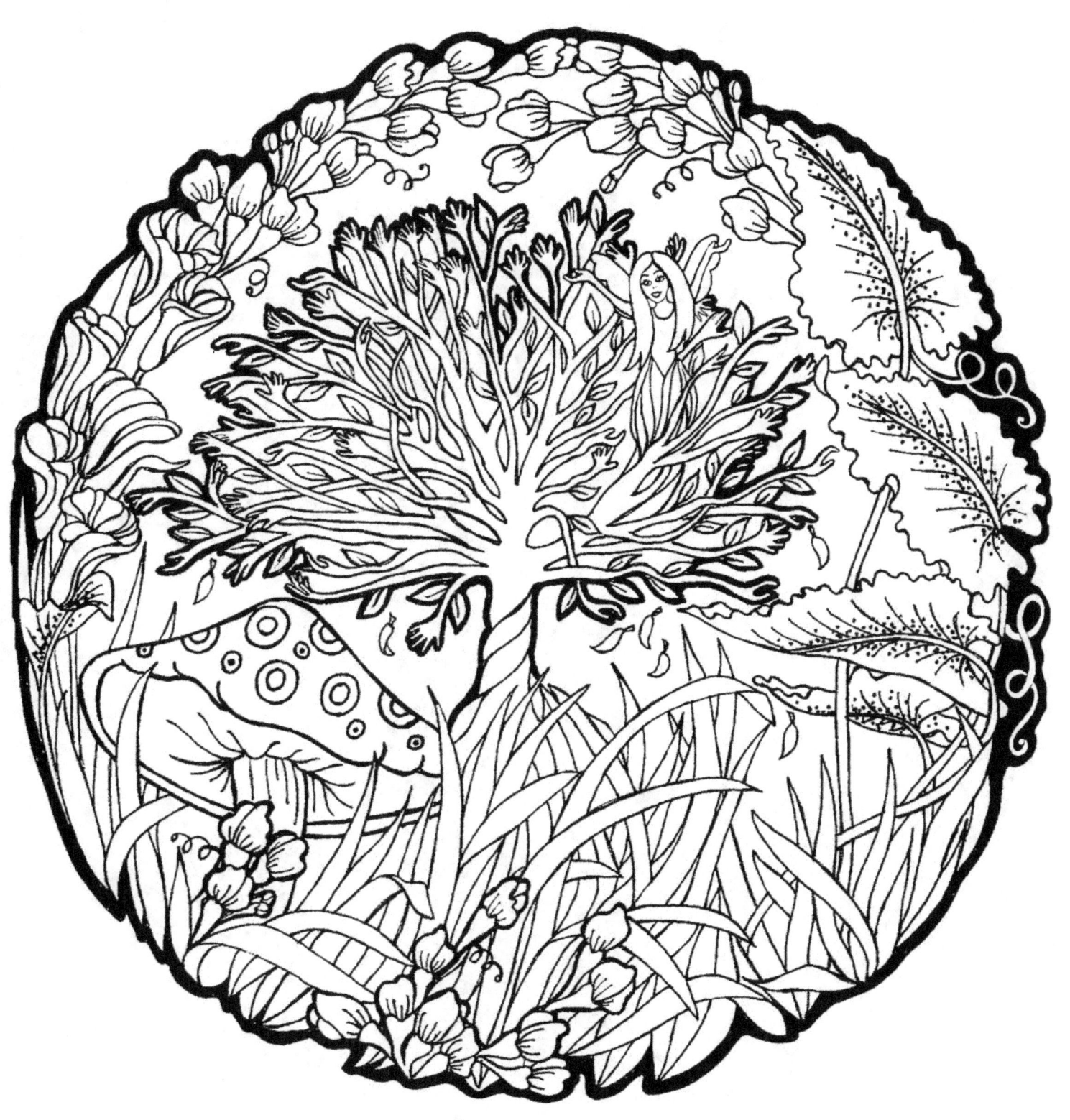

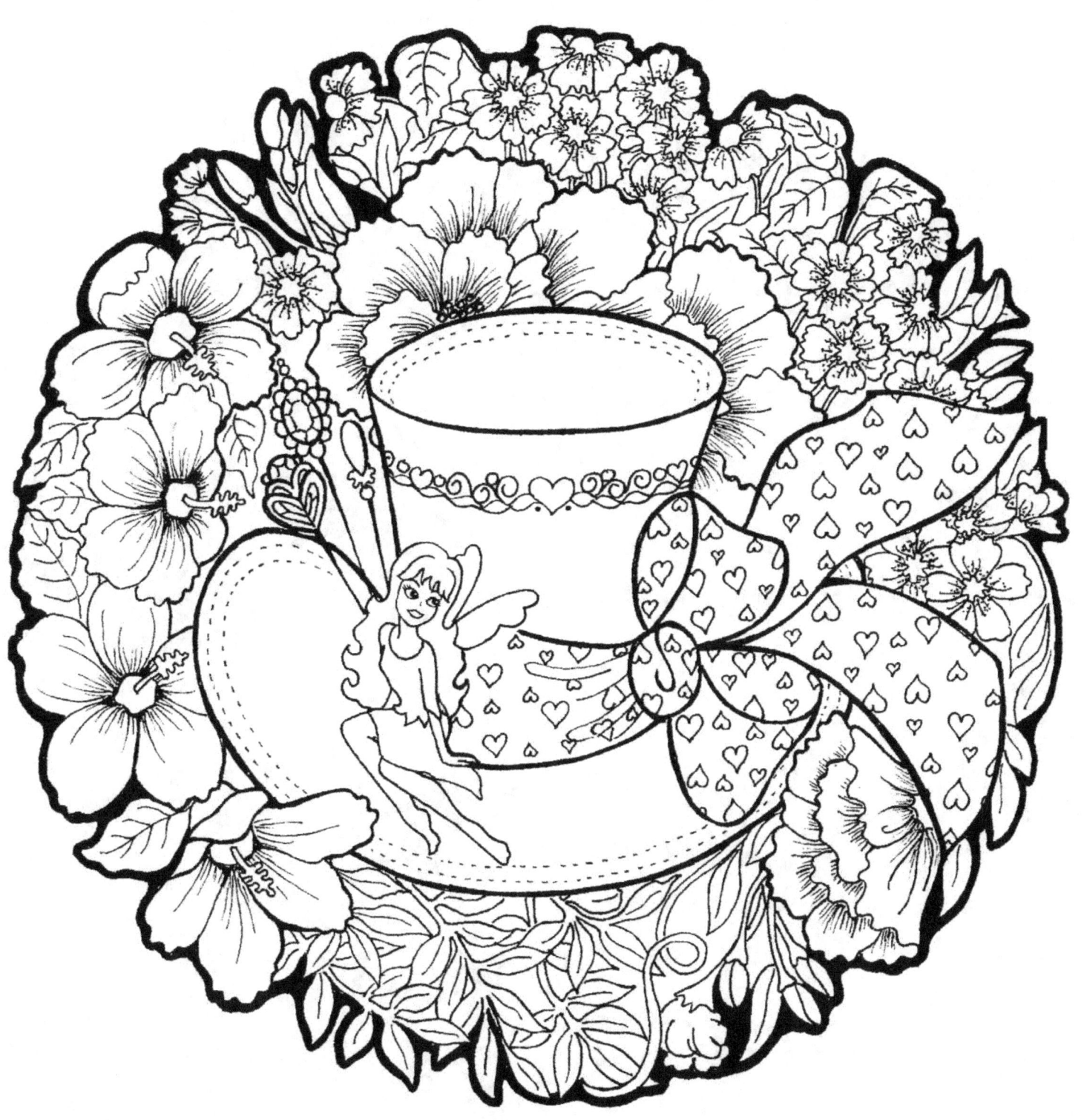

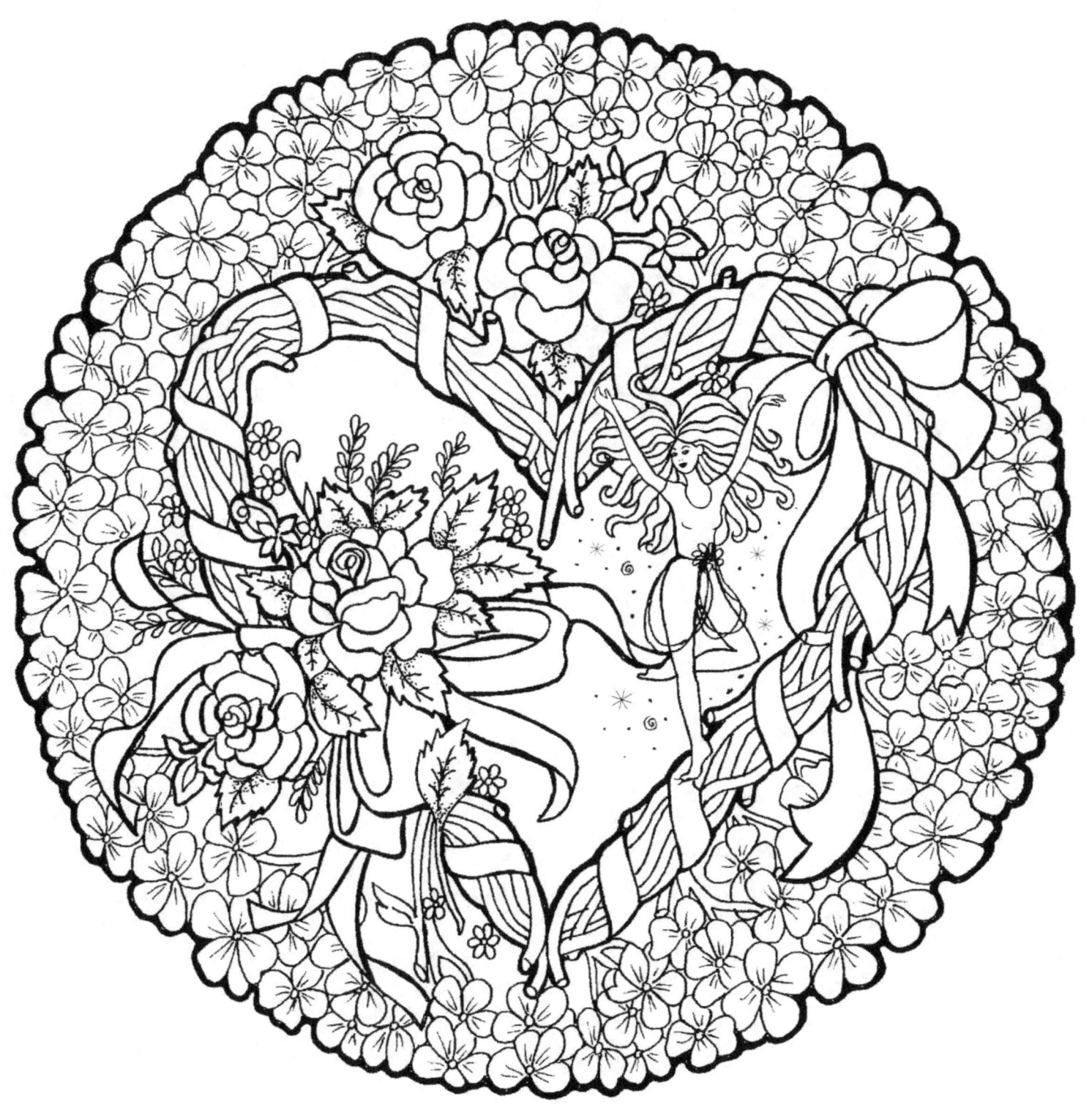

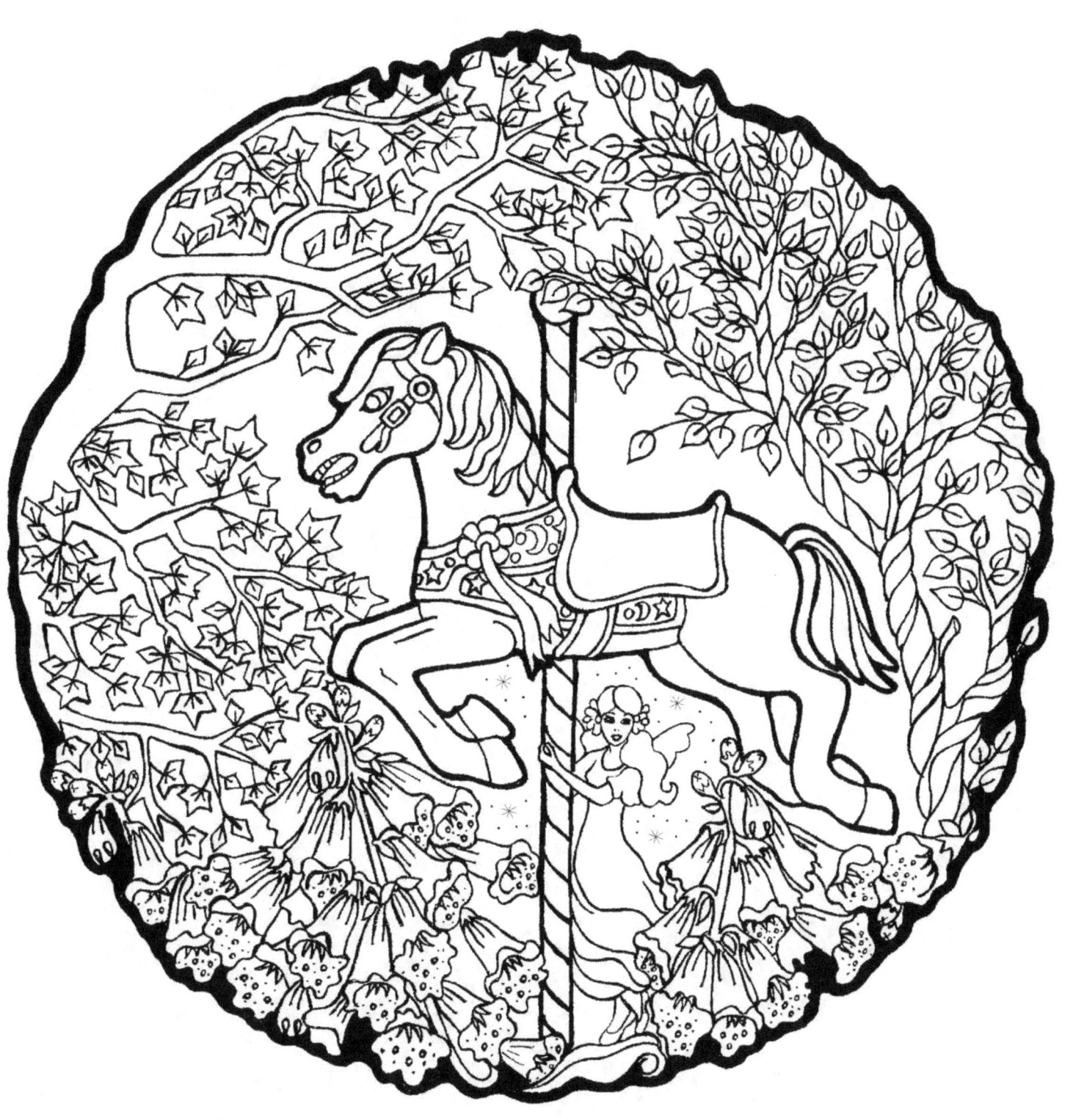

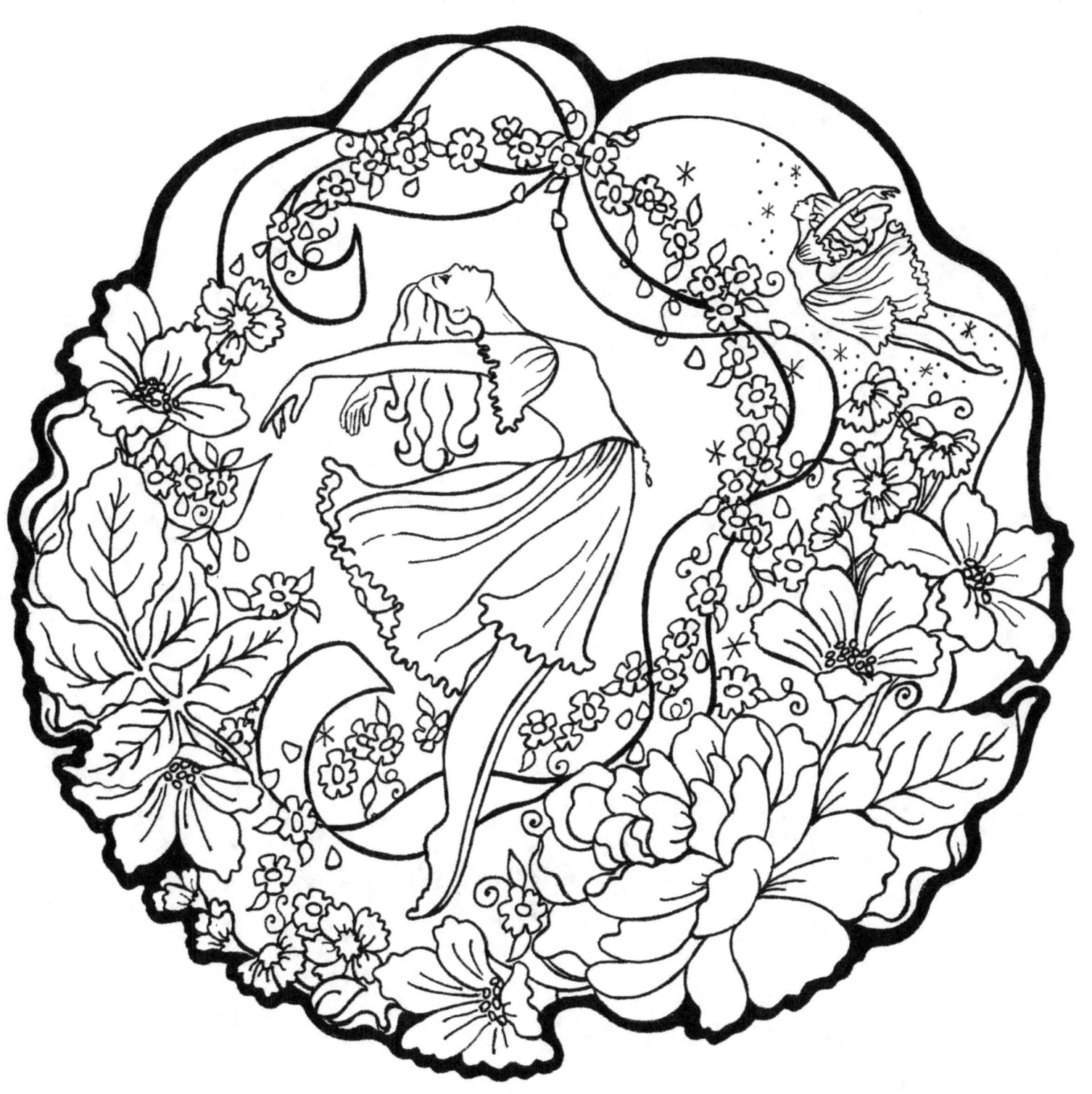

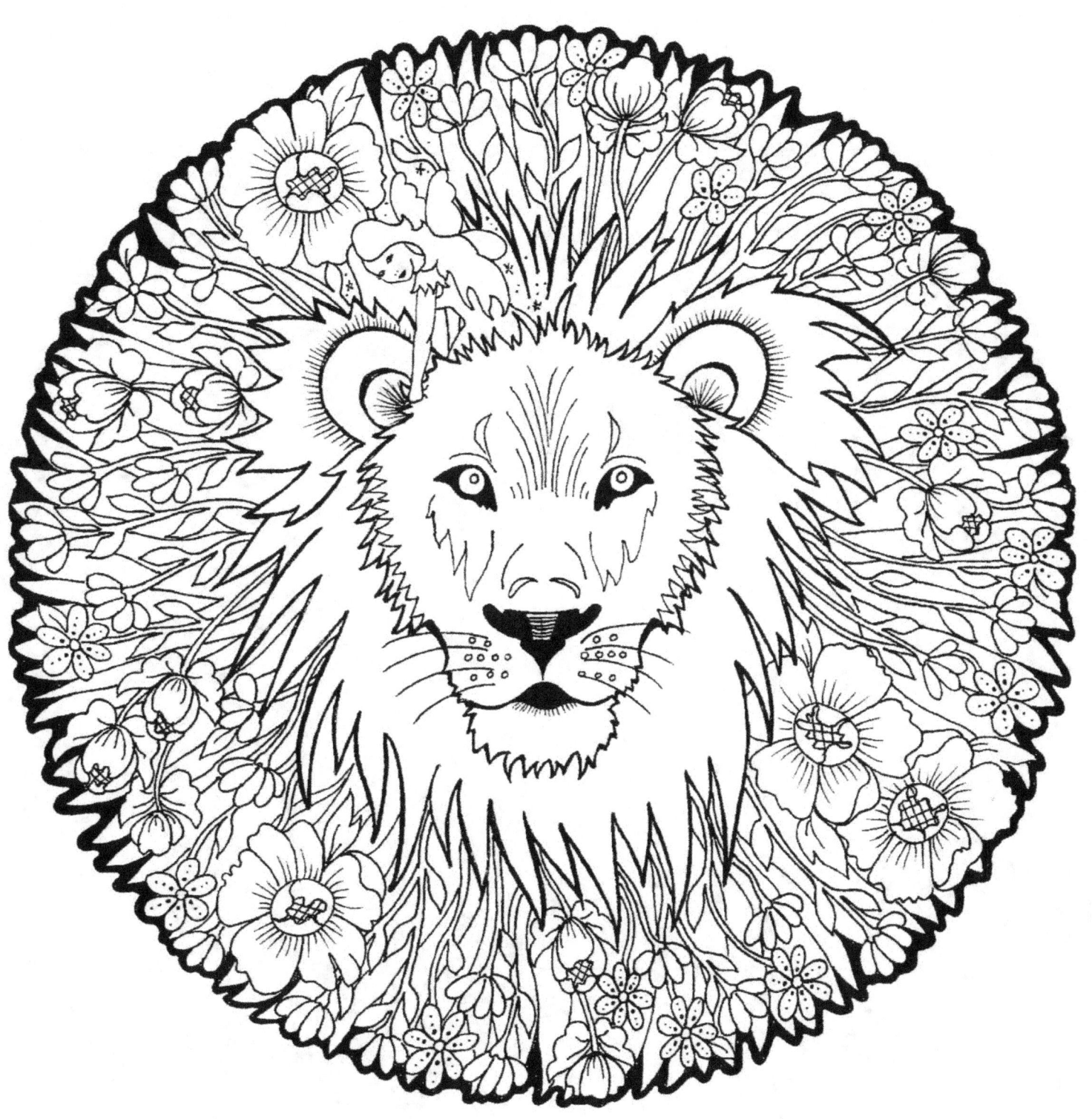

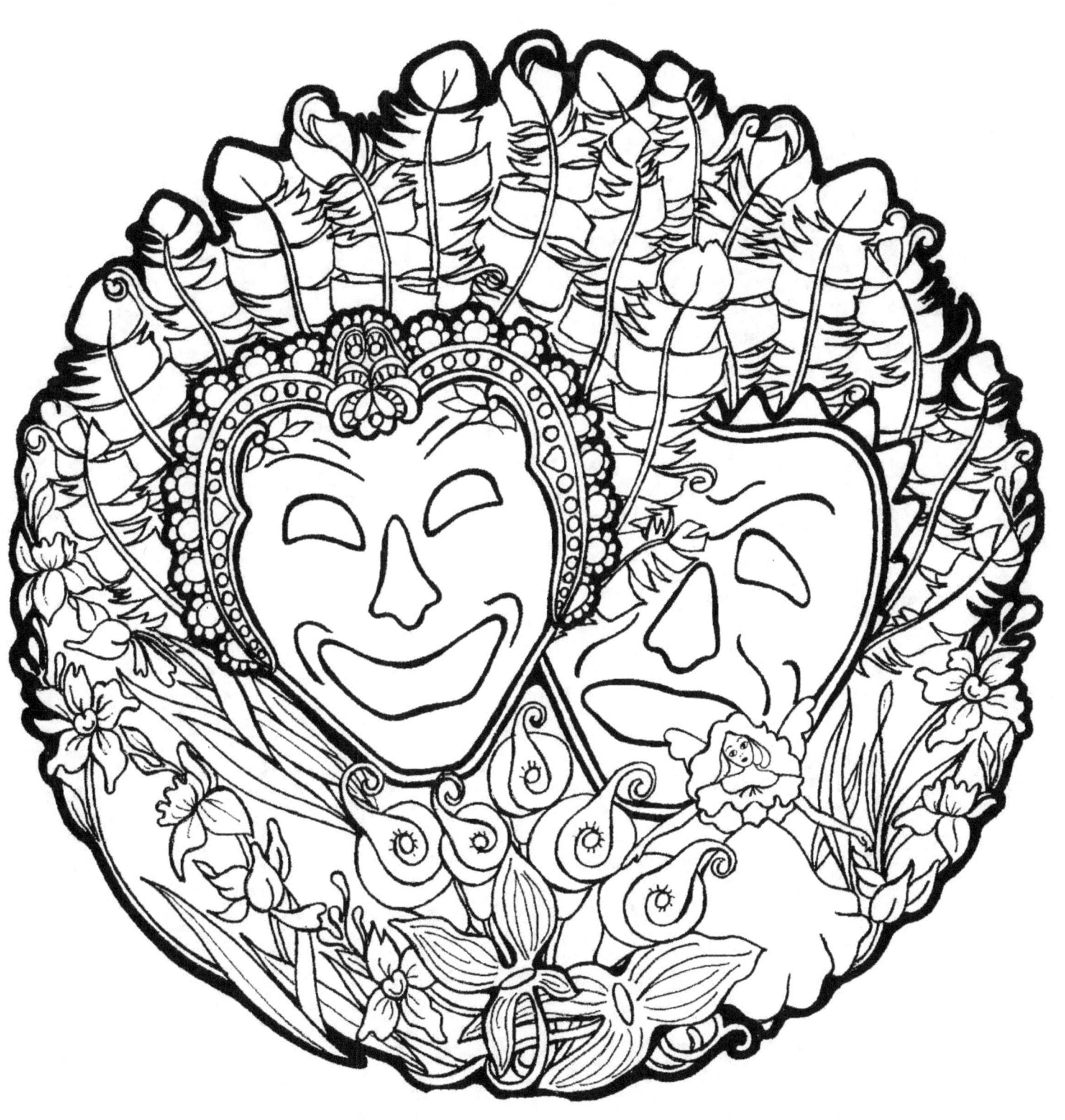

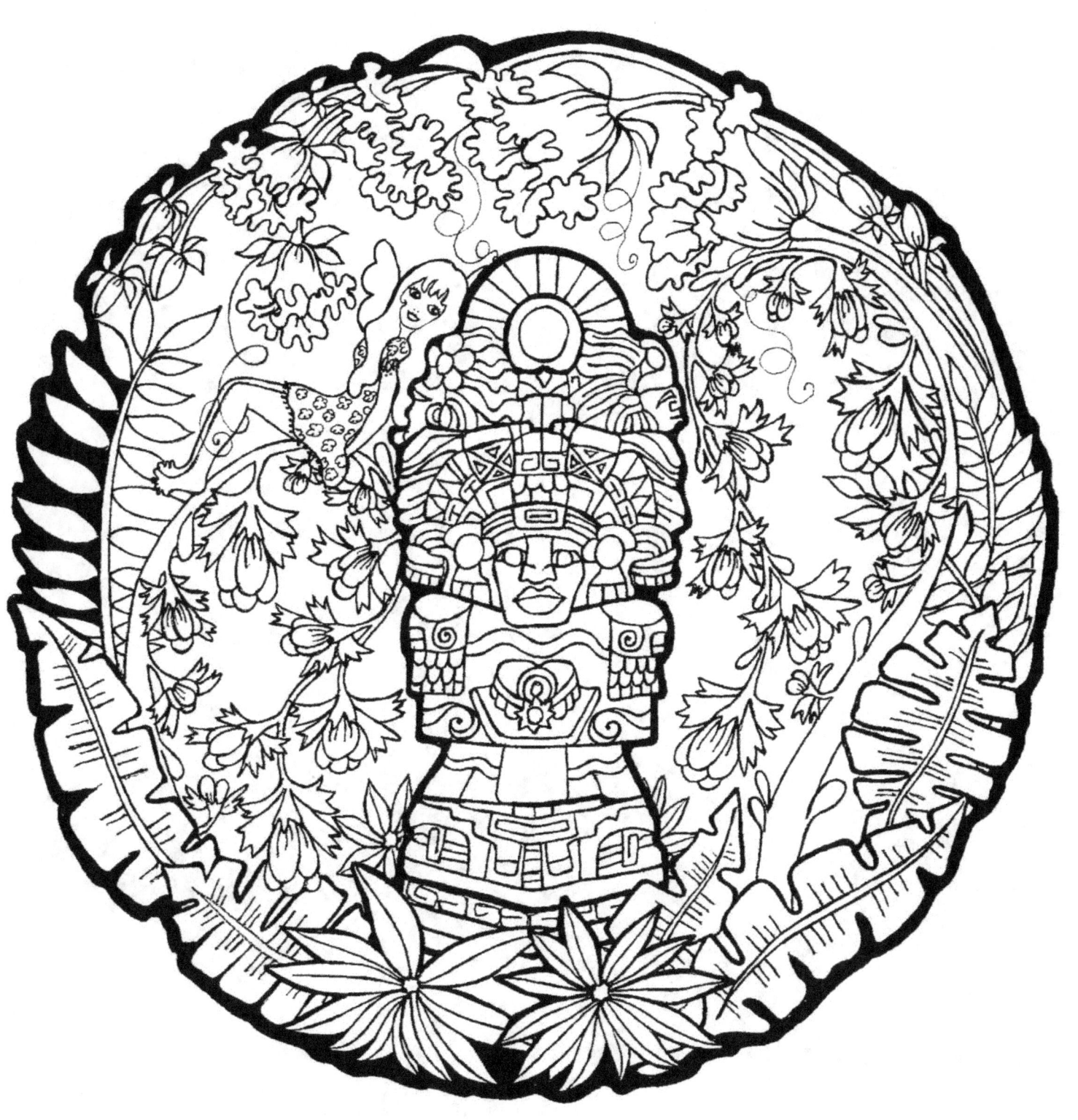

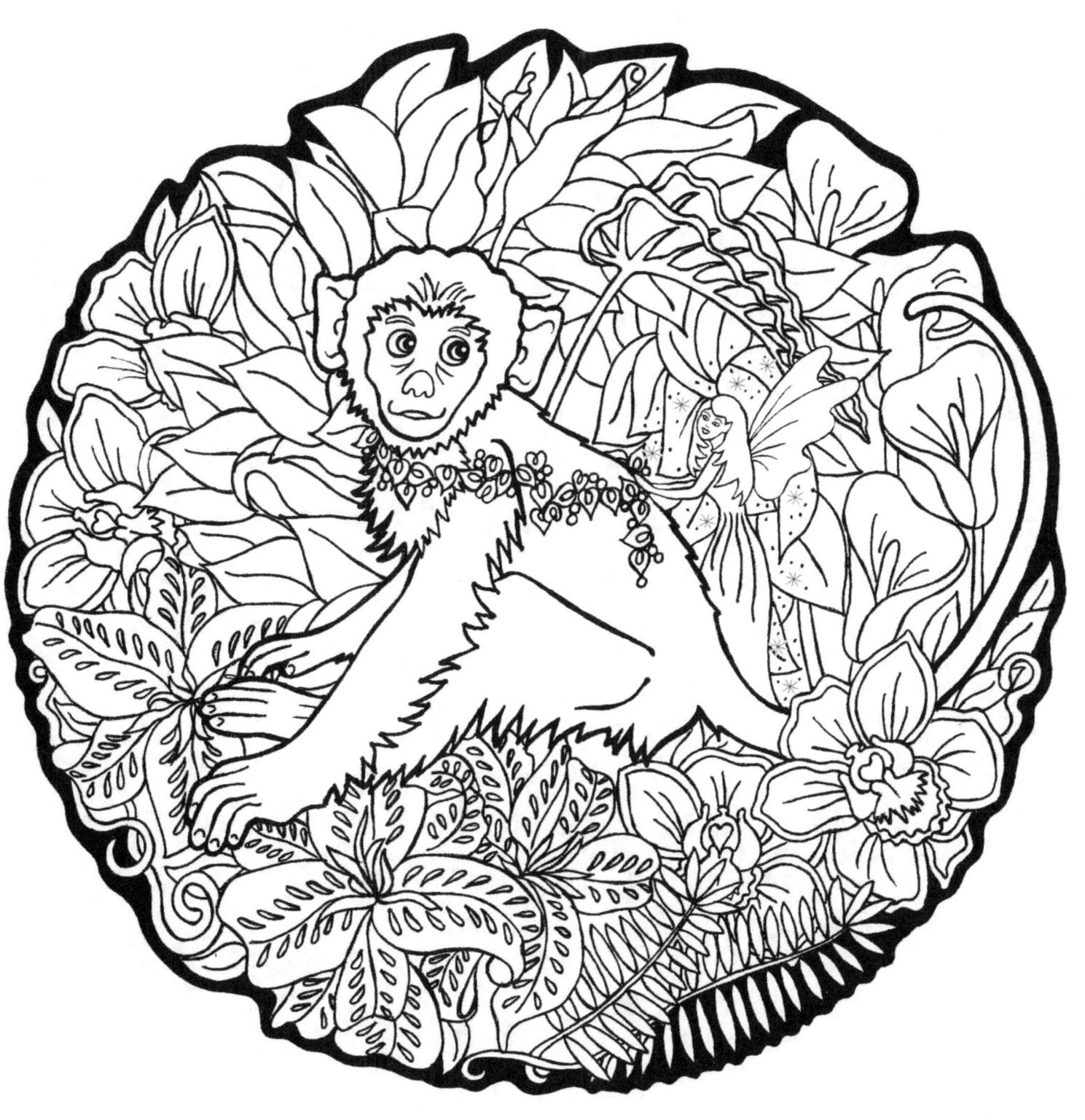

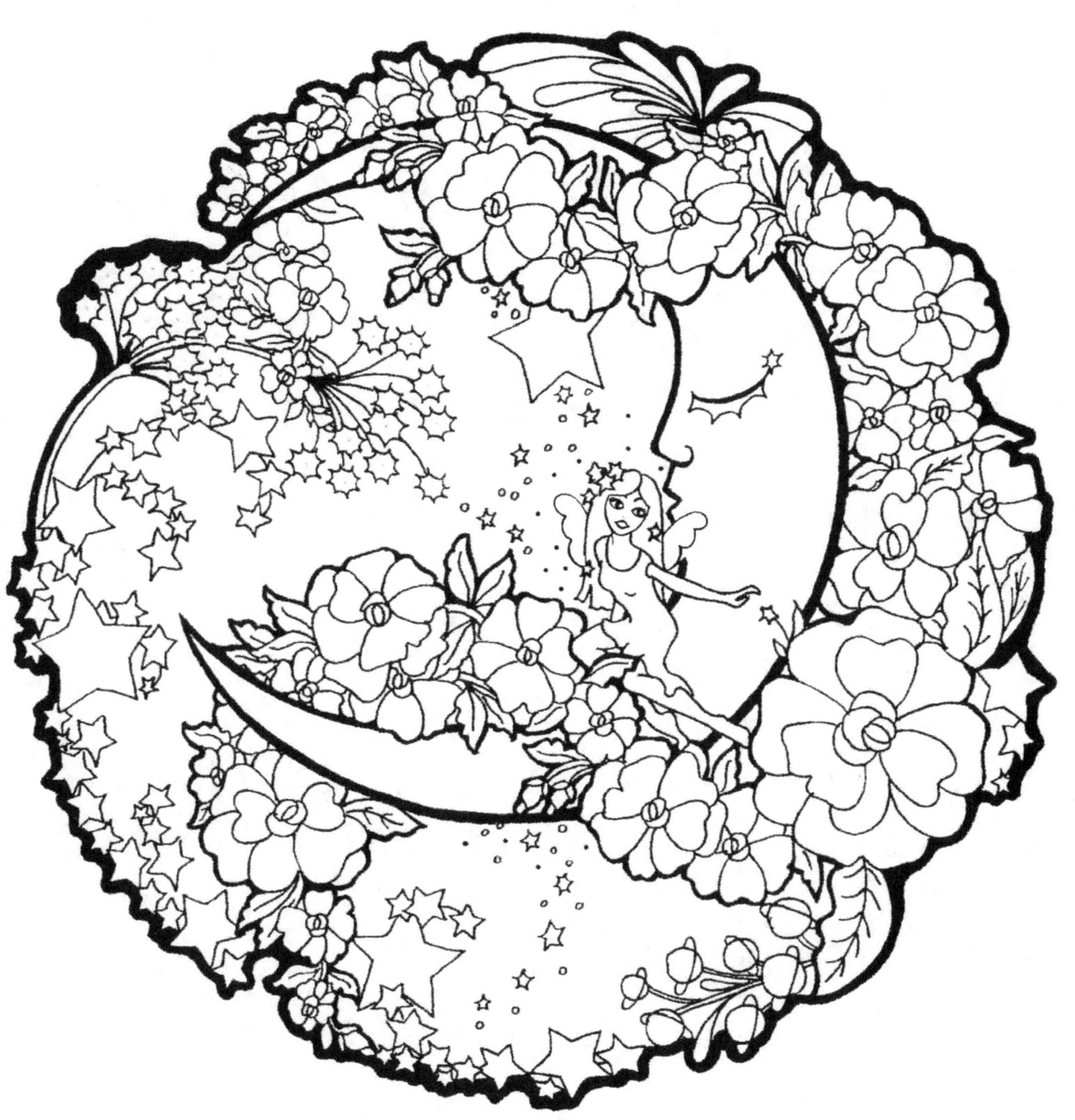

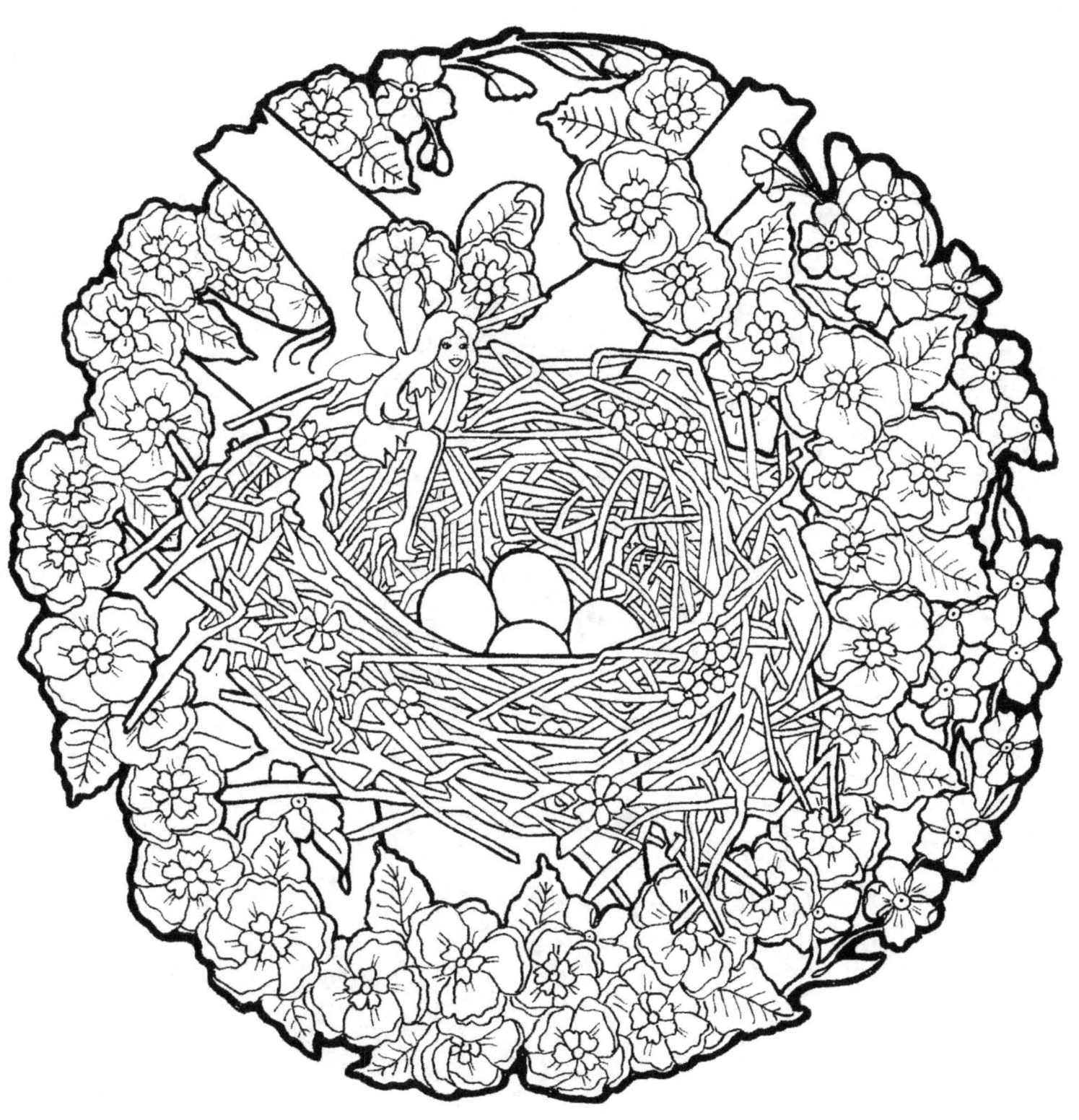

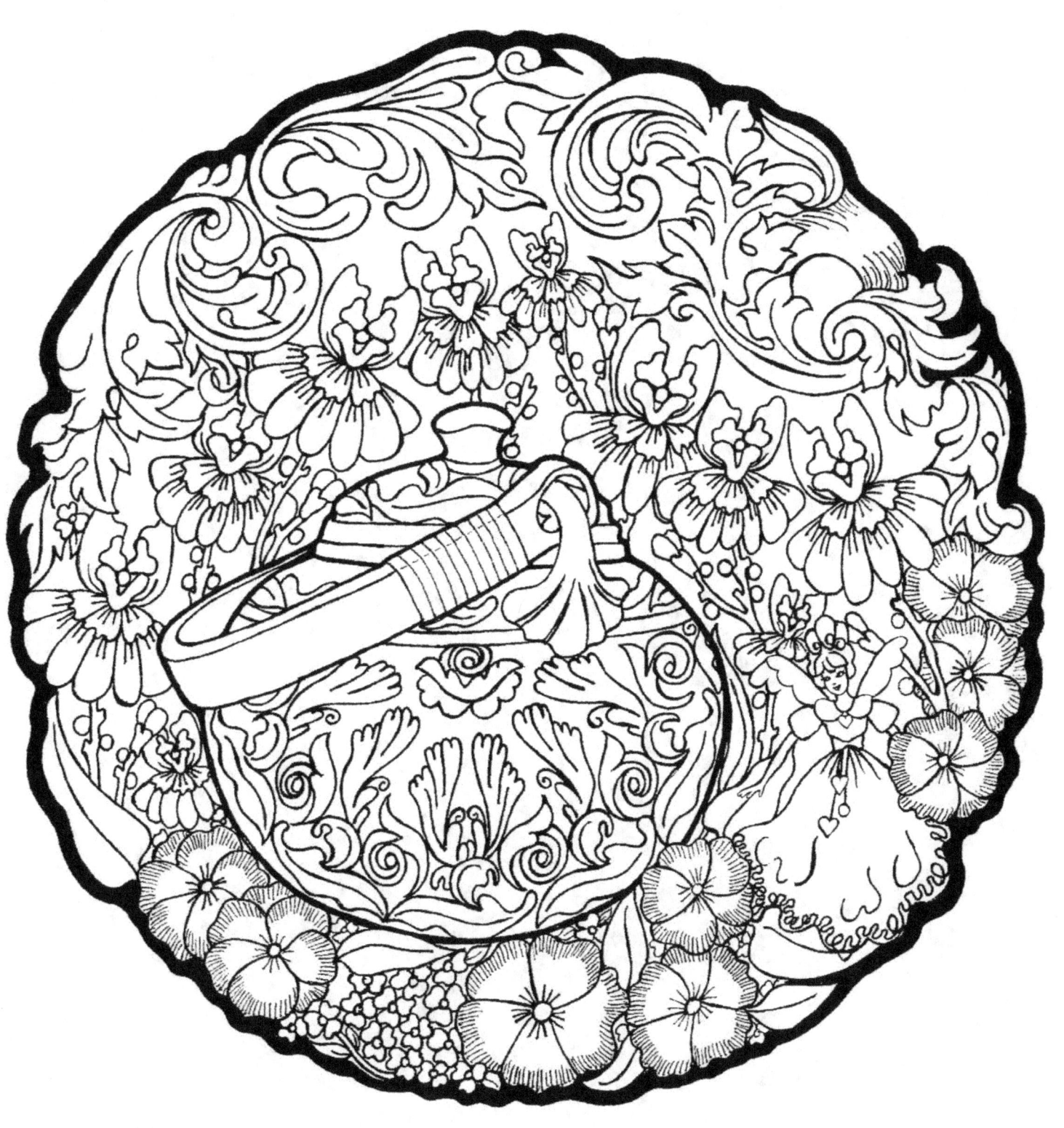

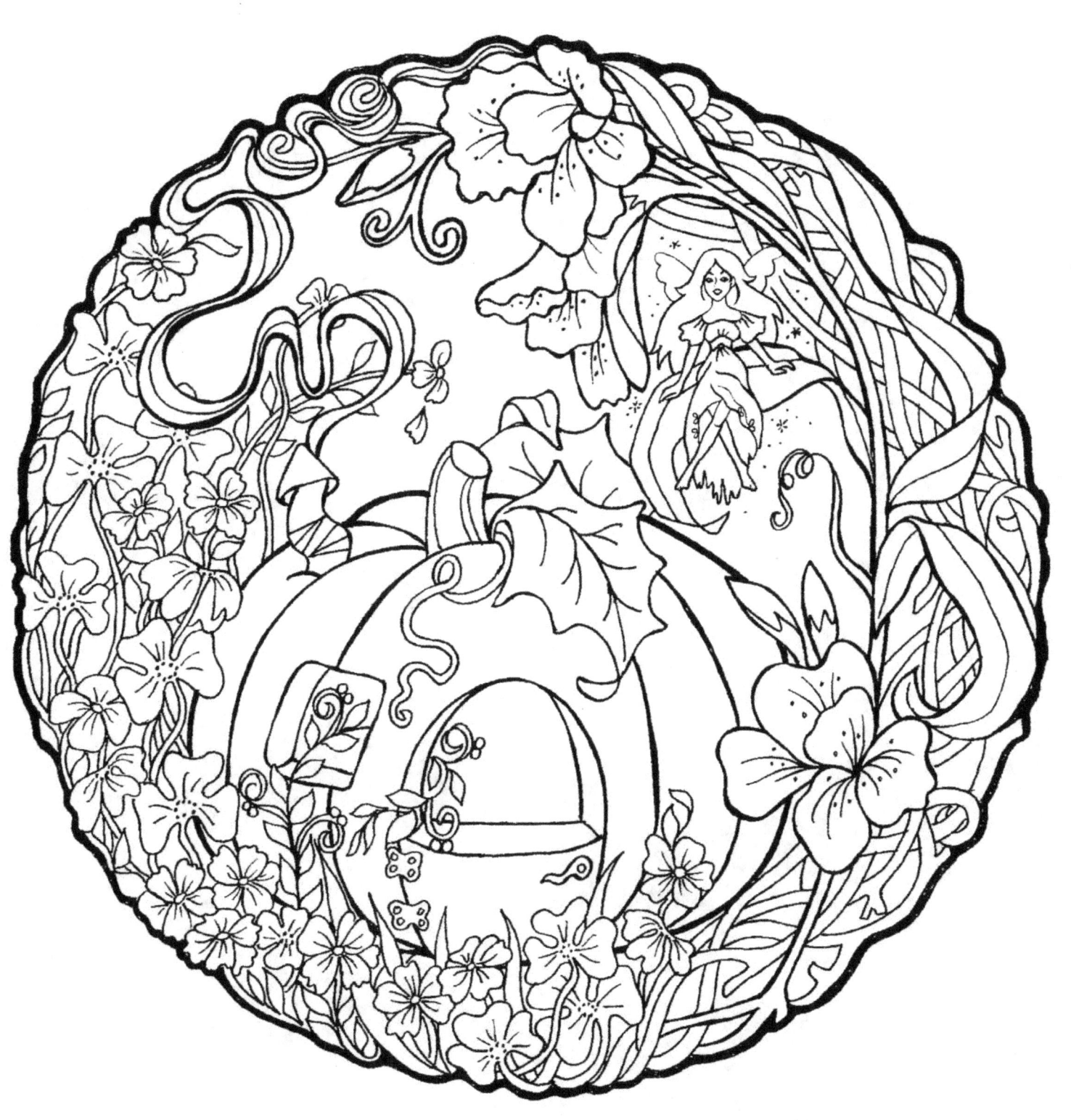

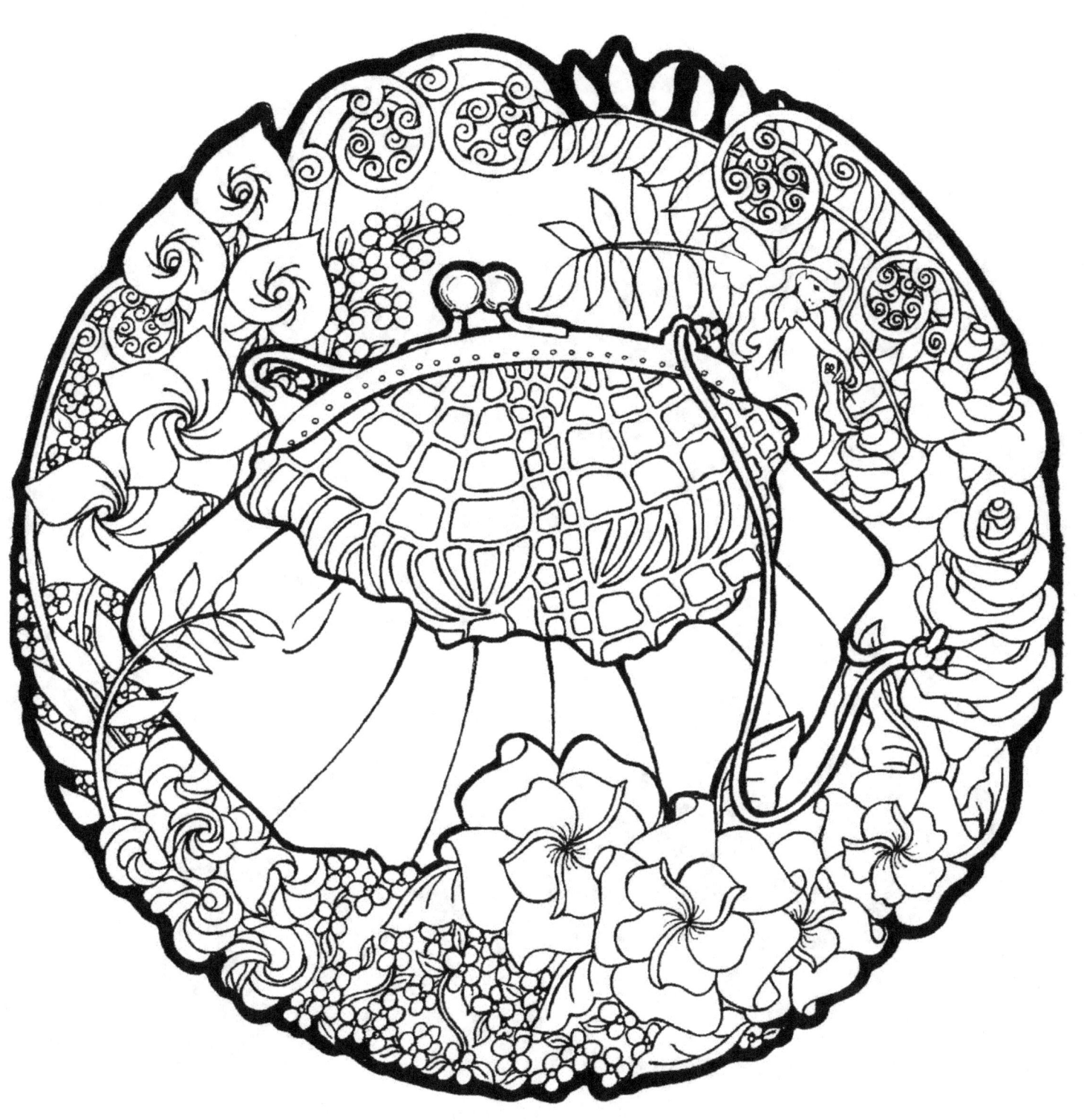

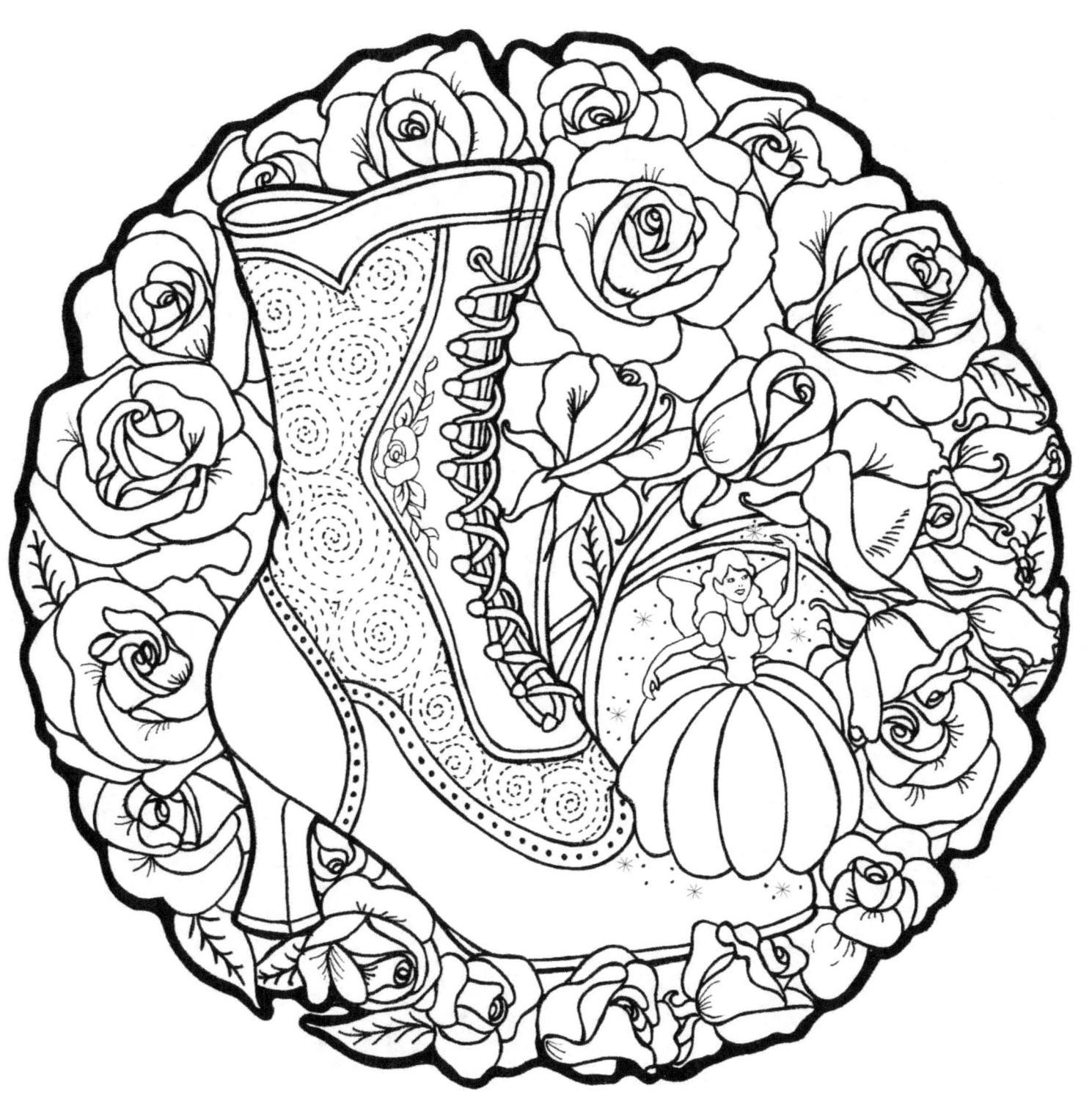

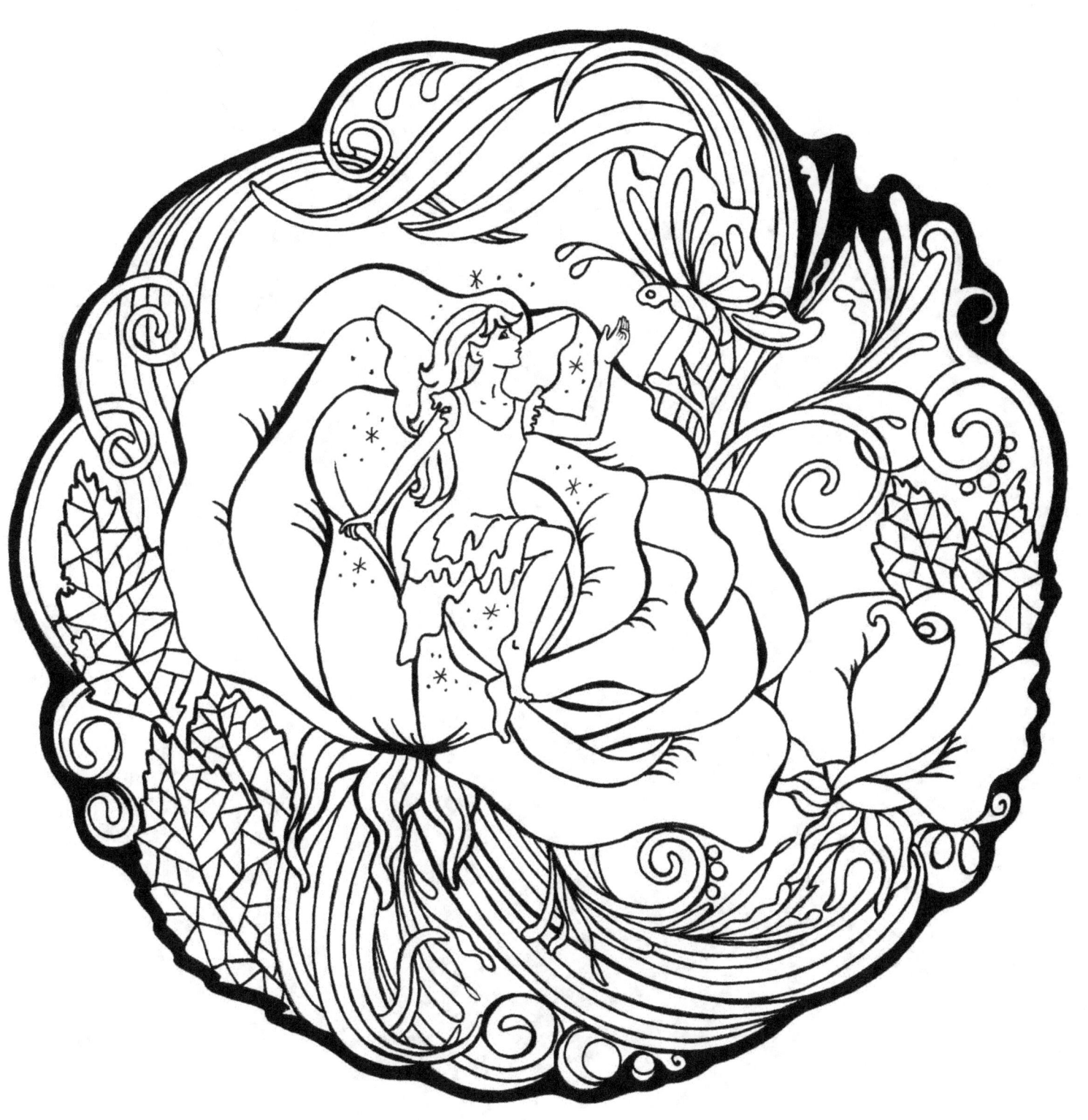

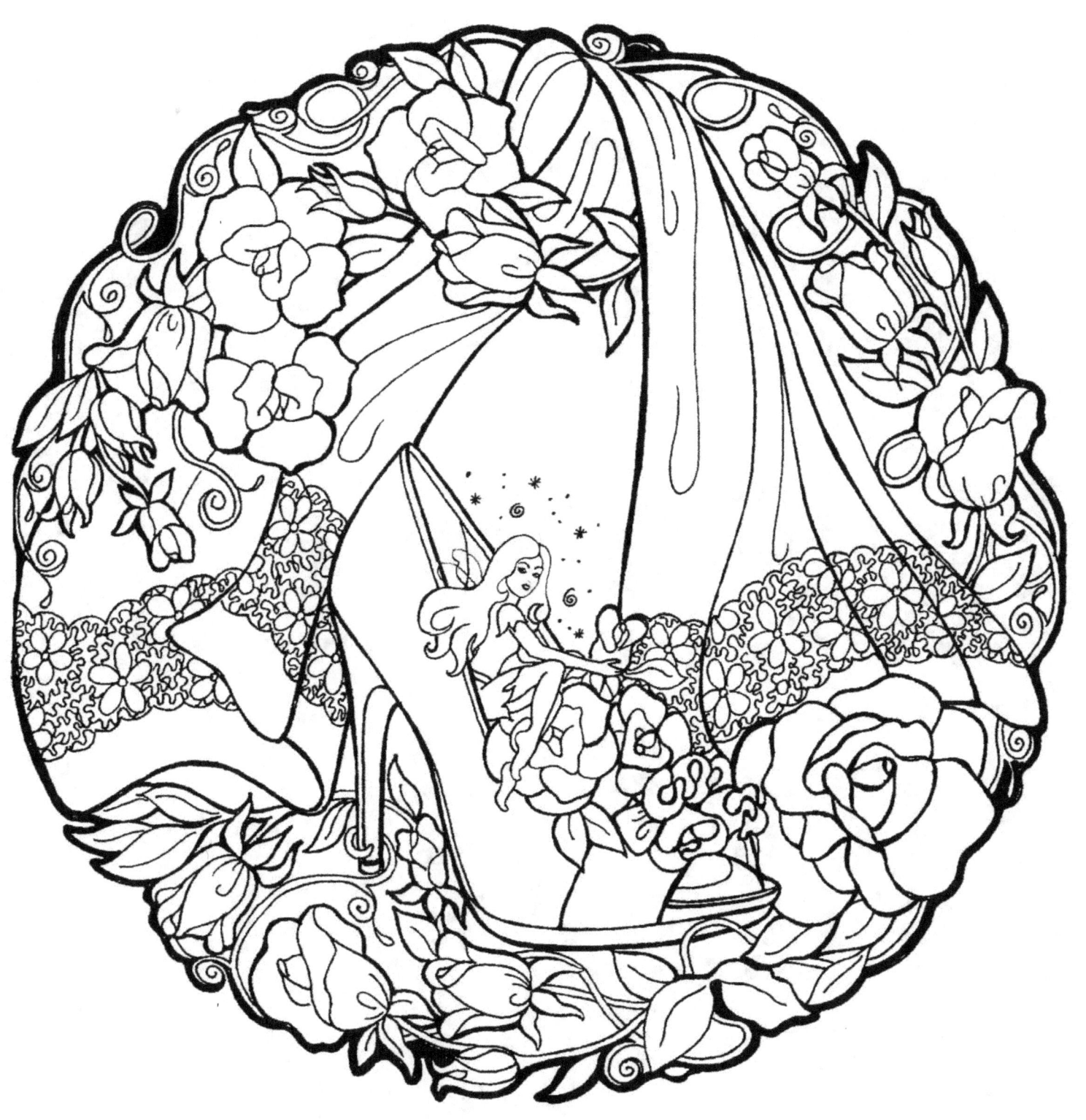

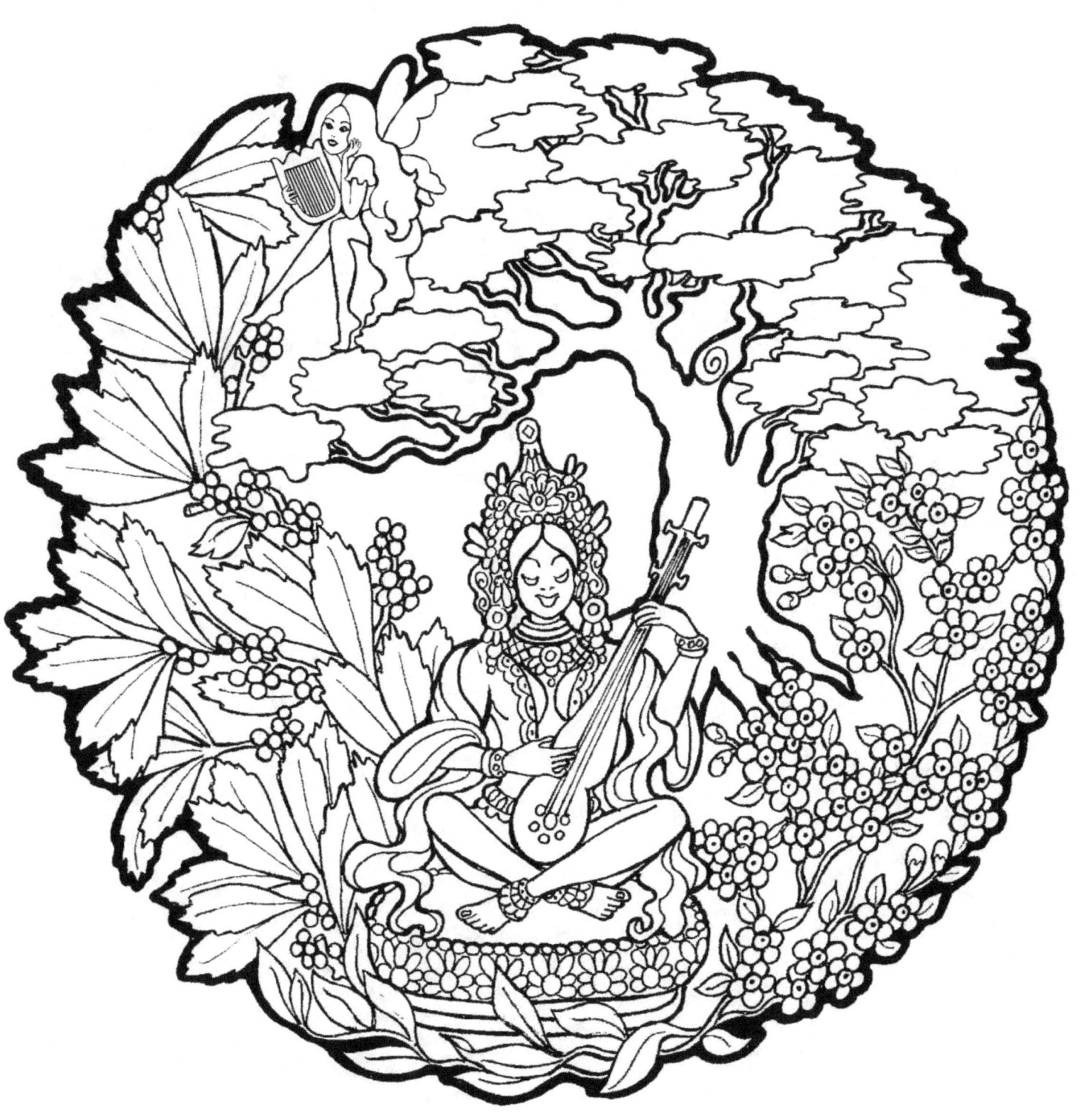

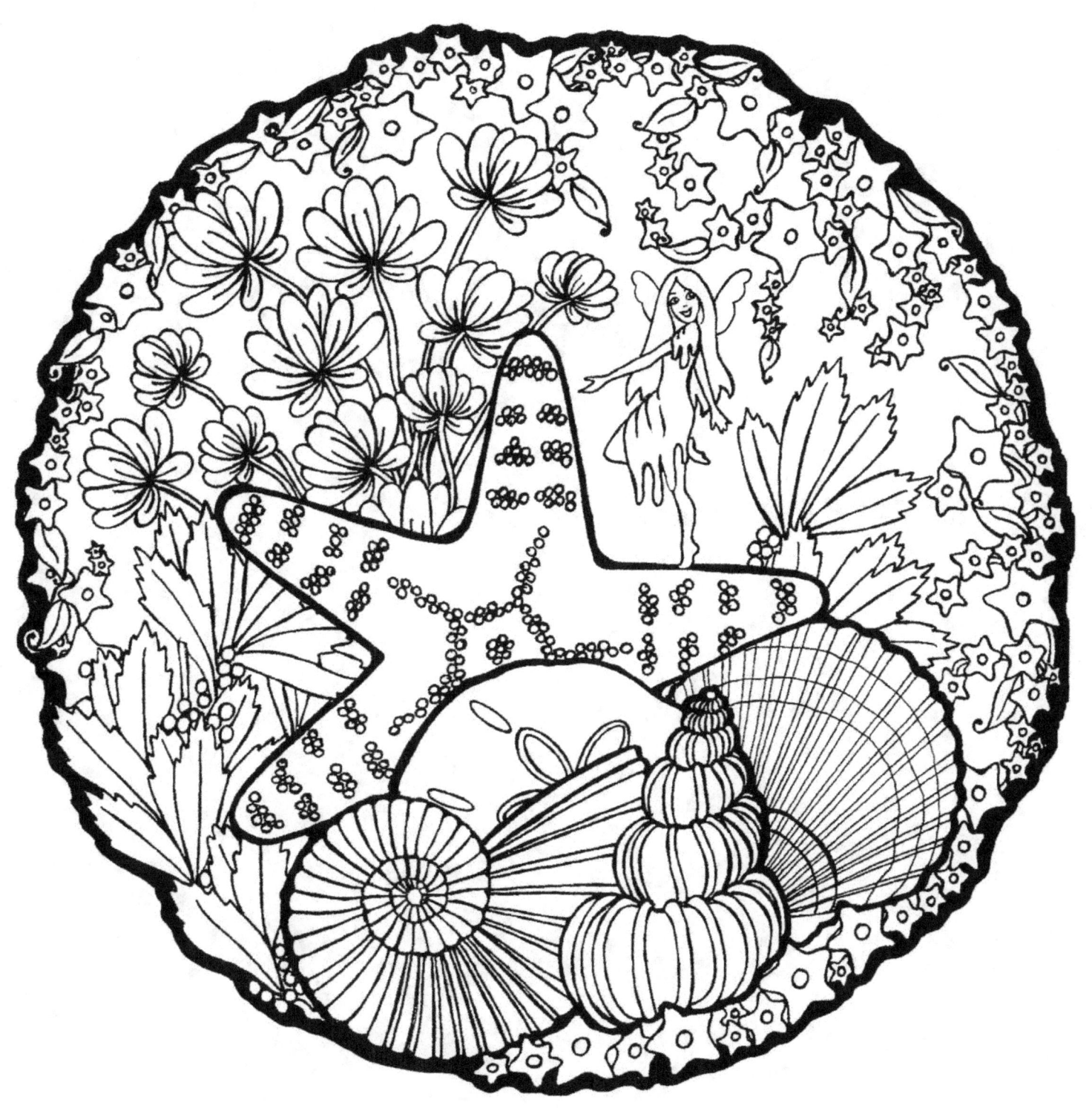

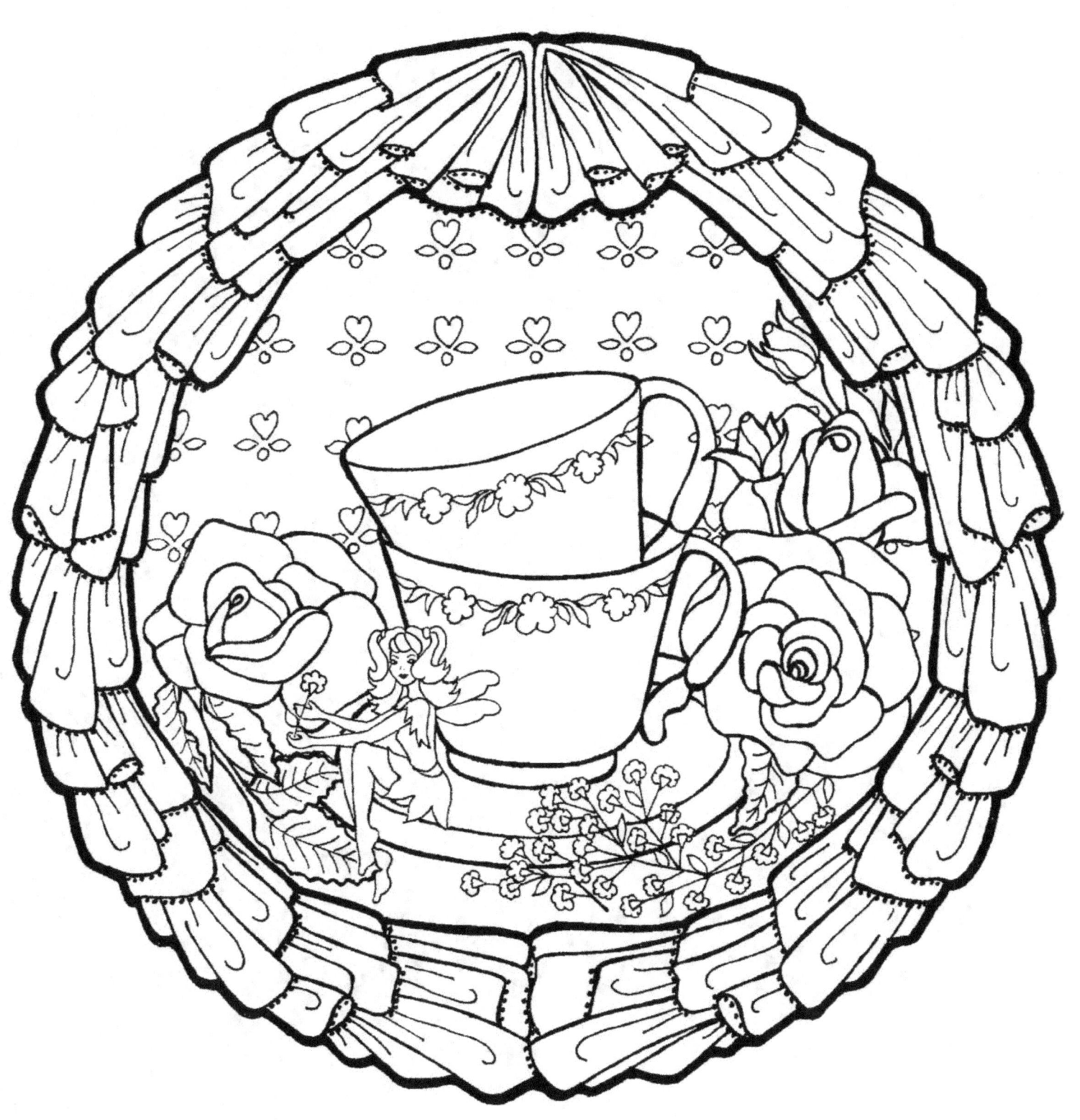

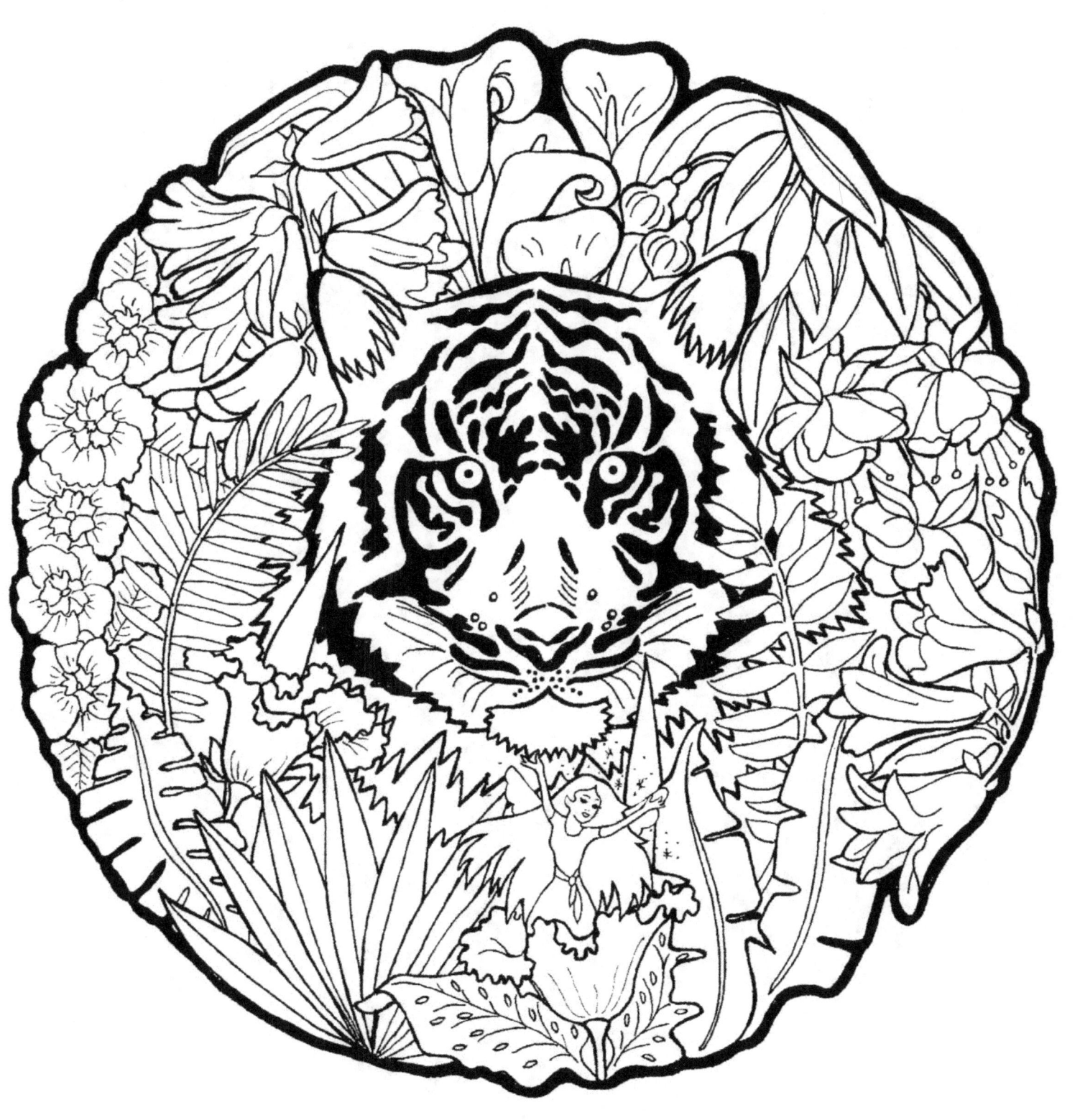

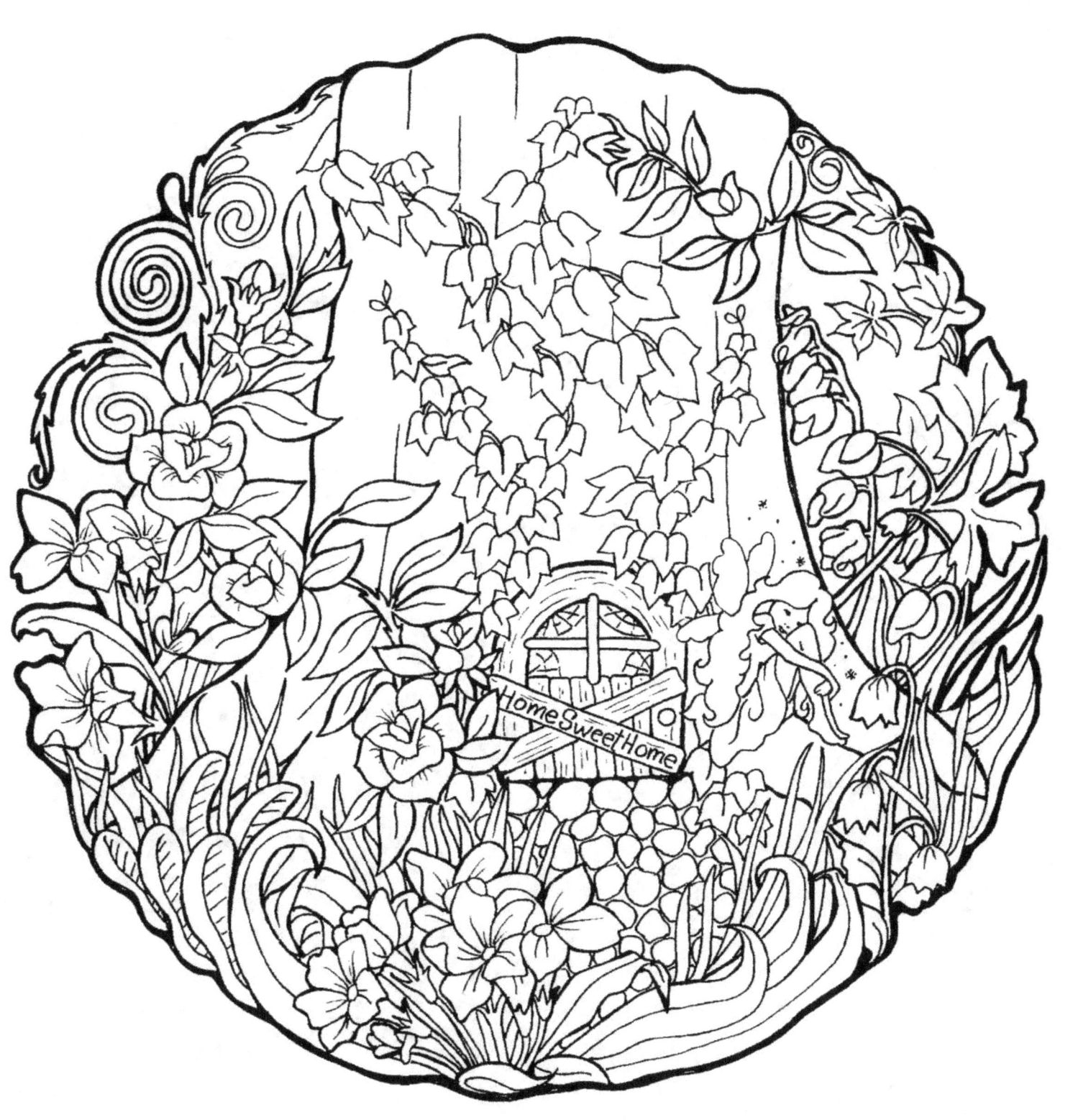

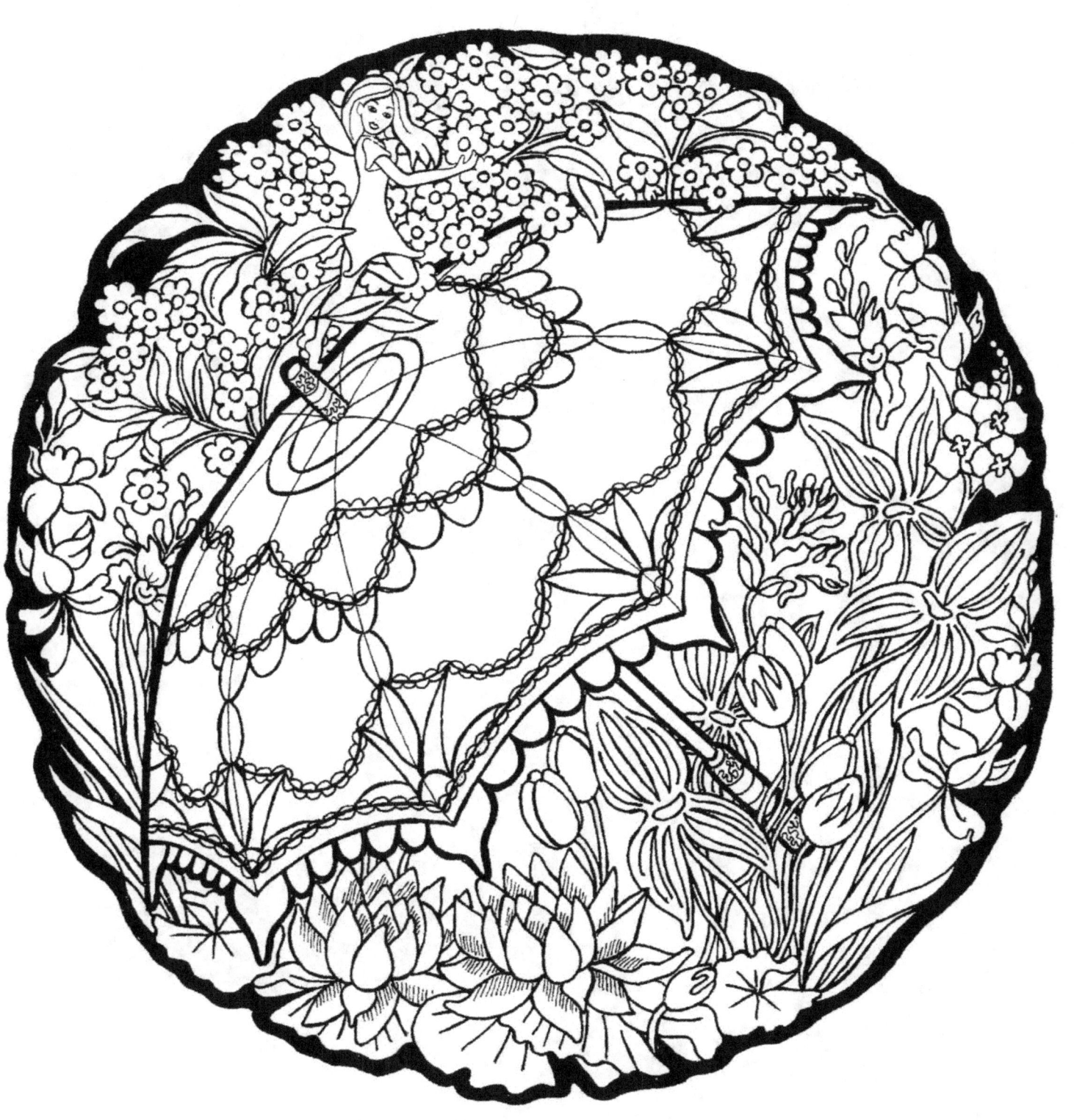

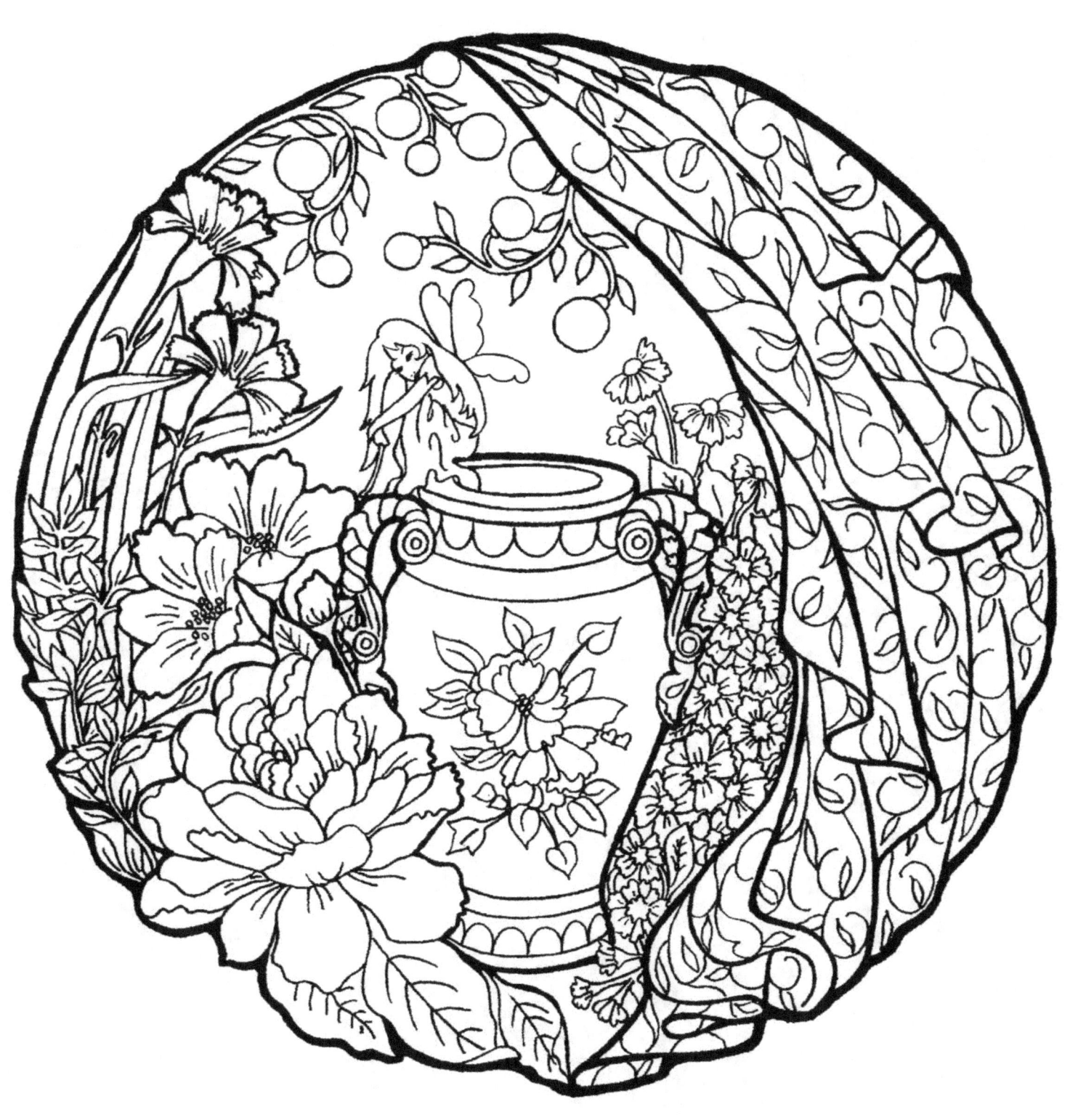

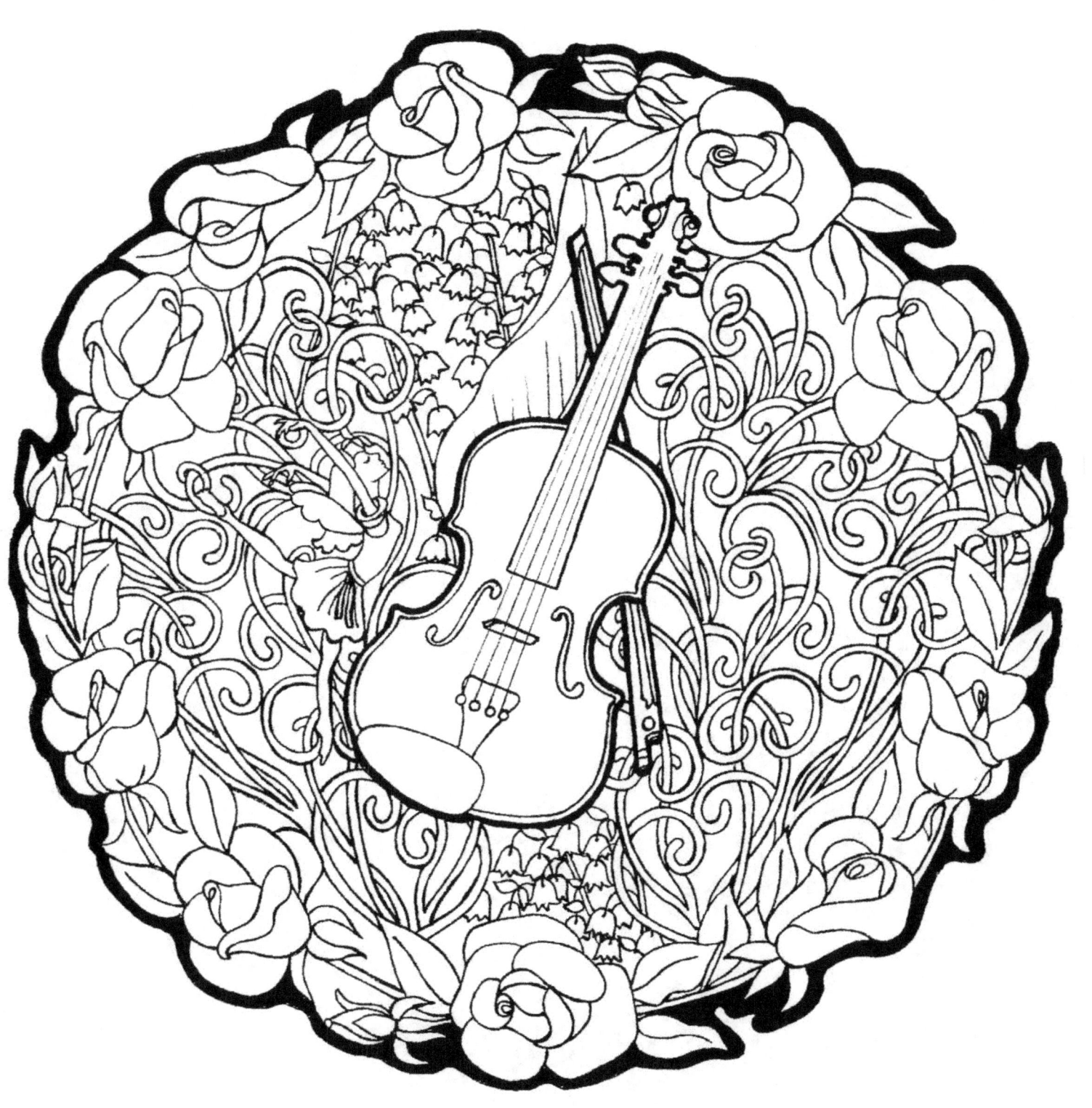

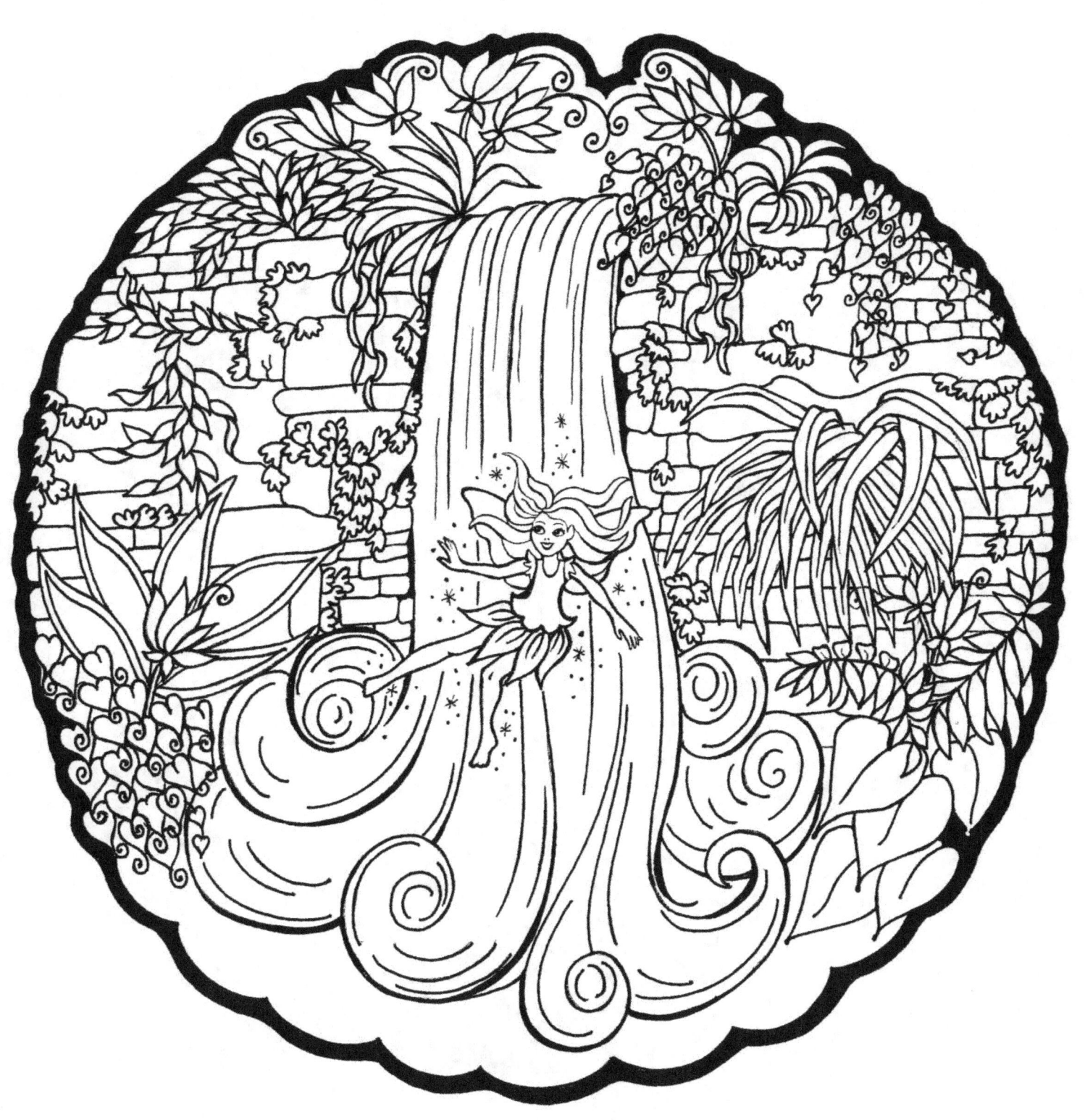

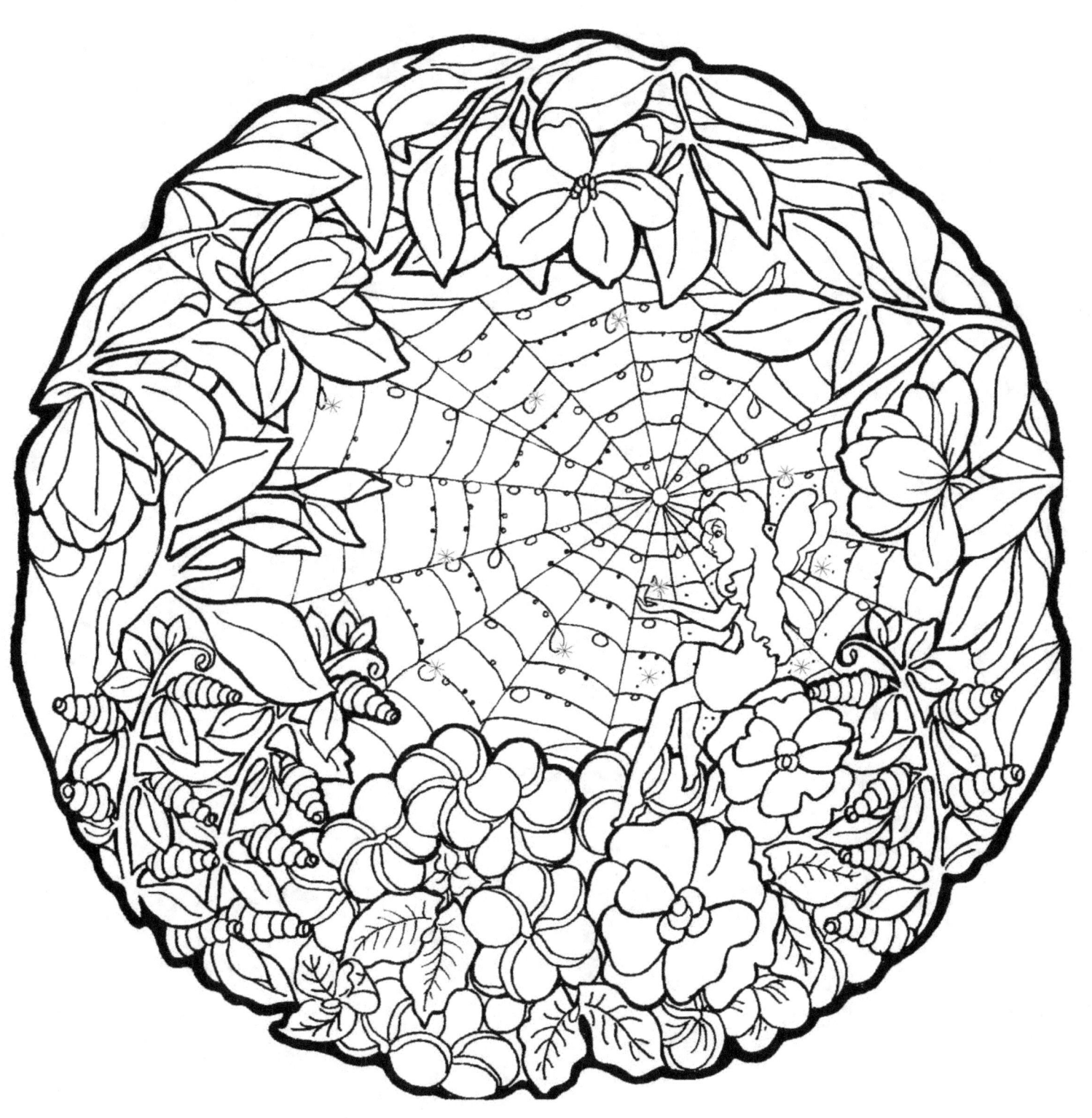

From Marie Scott, the artist

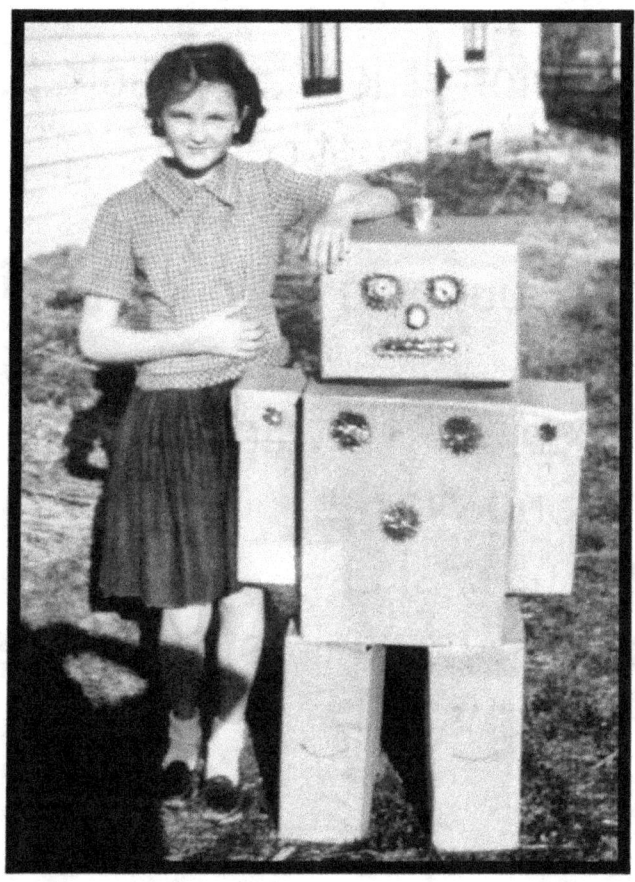

Here I am with Rochester Robot, my funny 4th grade creation--proof that I have loved imaginative characters since childhood.

In Saxon Alley, I still love to cut, paste, sculpt, draw, and color, and will always be an artist joyful in the making.

I hope you coloring artists will have fun combining your skills with mine in making your world a happier place. Doing artwork will always be a great antidote to the ills of the world.

Share your work and leave your comments at saxonalley.blogspot.com, and enjoy!

For more information and inspiration, visit saxonalley.blogspot.com.

Watch for our other coloring books:

Celtic-Inspired Snowflakes
Dragon Snowflakes
Flower Snowflakes
Whimsical Snowflakes
Heart Charms

I dedicate this book to all the lovely ladies in my life, and to all you who love to color. May your lives be filled with many magic moments!

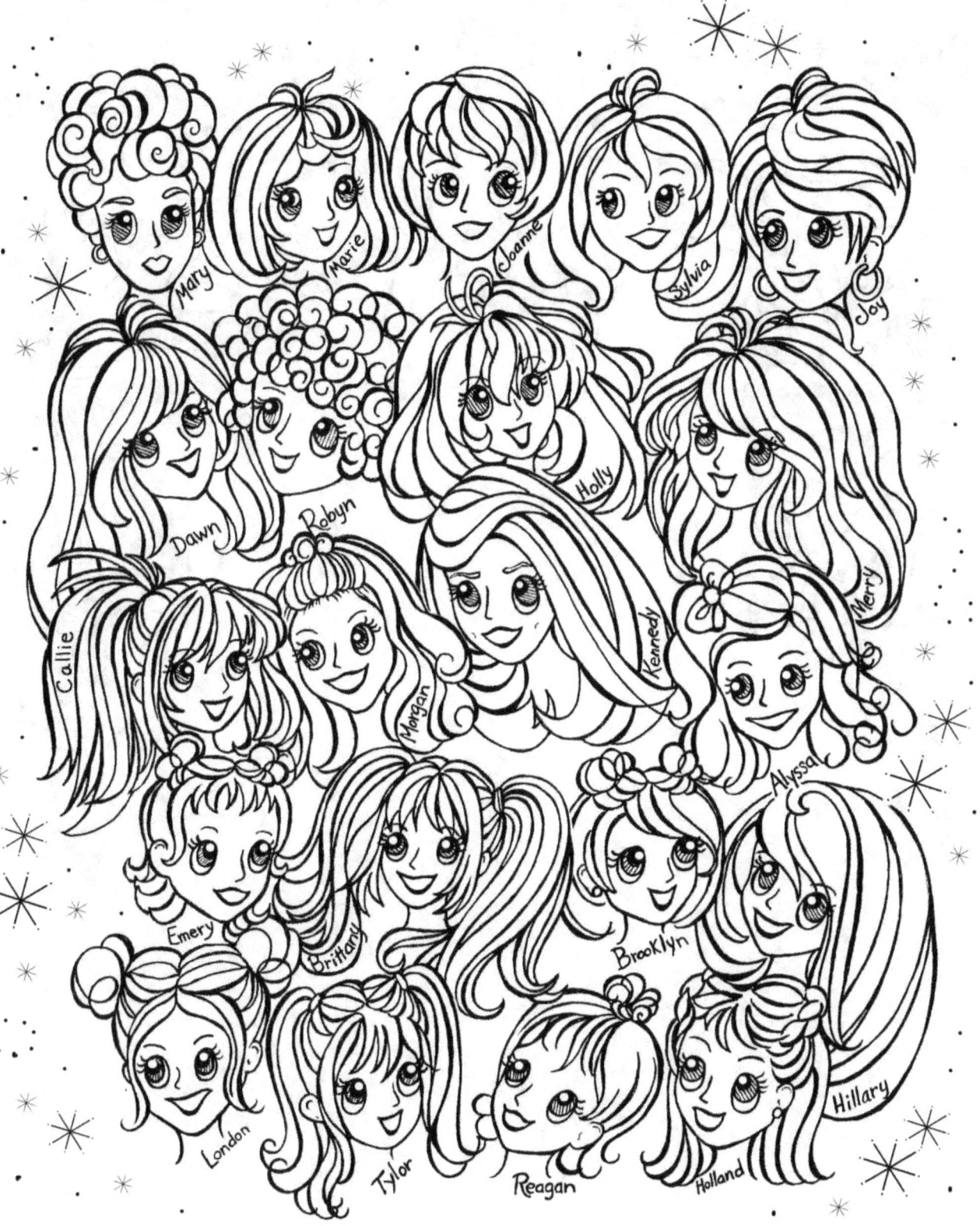

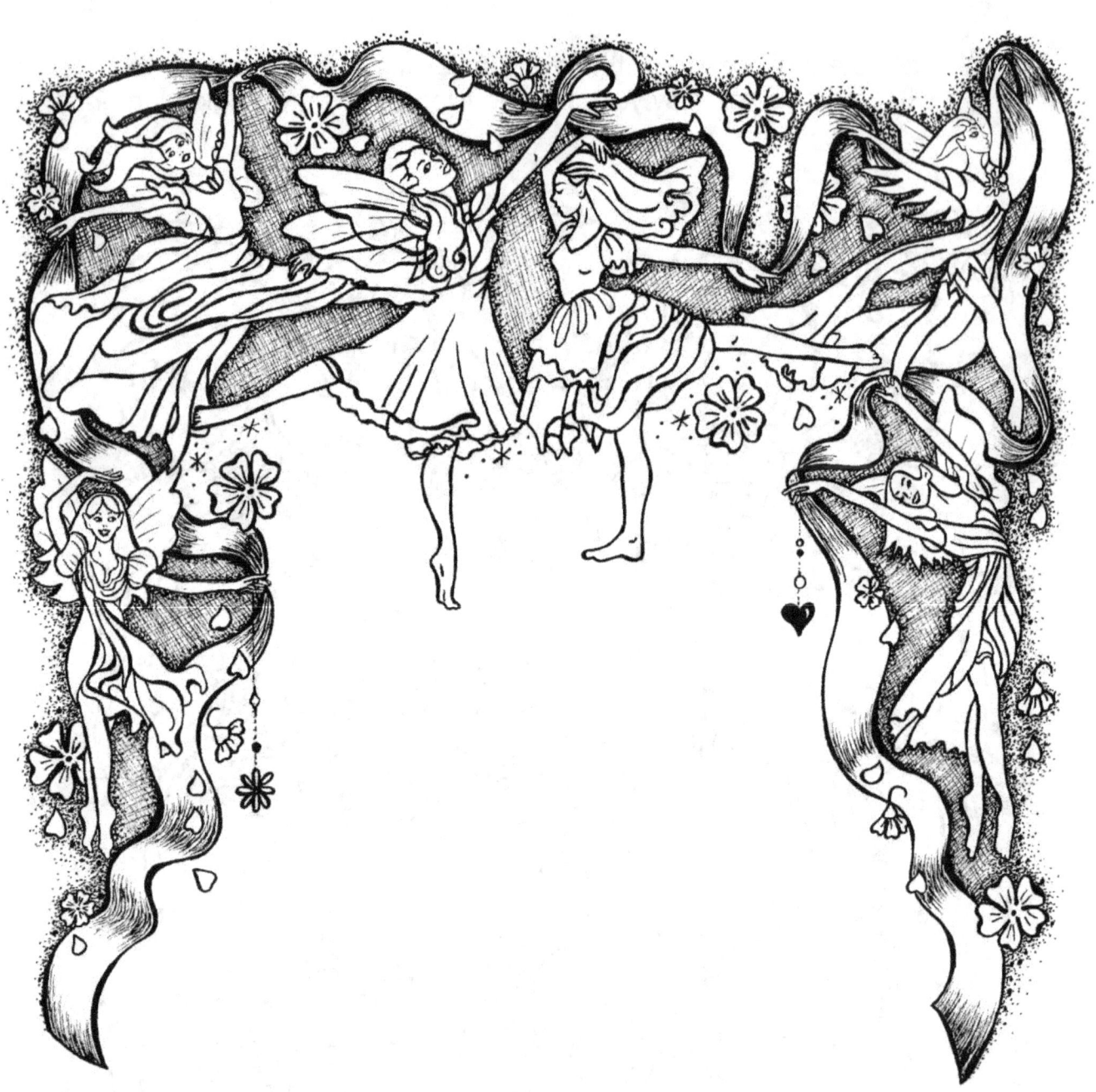

www.ingramcontent.com/pod-product-compliance
Lightning Source LLC
Chambersburg PA
CBHW081206180526
45170CB00006B/2235